THE CREATIVE
DARKROOM
HANDBOOK

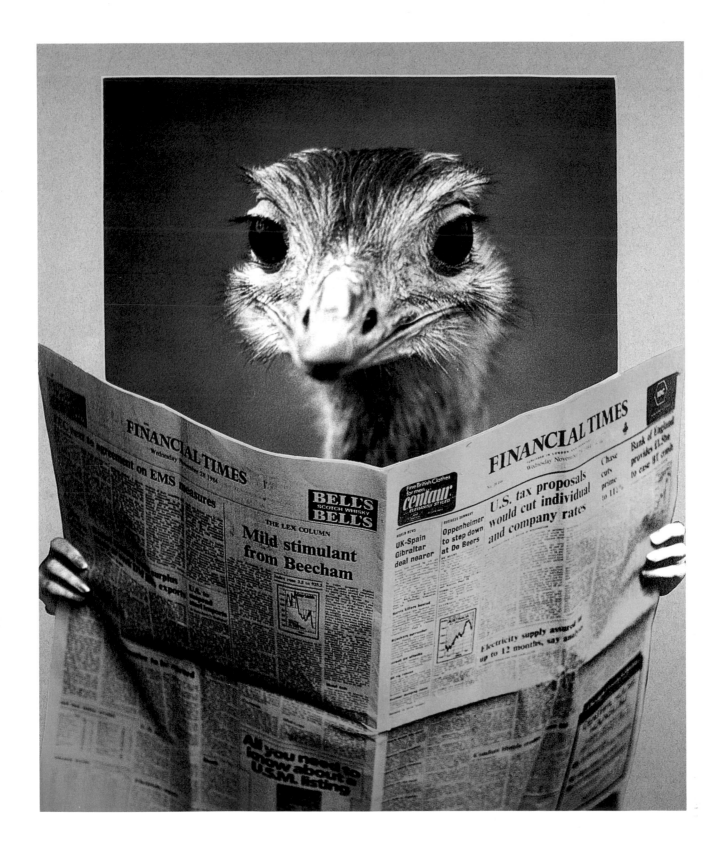

THE CREATIVE DARKROOM HANDBOOK

A practical guide to more effective results

CHRIS WAINWRIGHT FRPS

CASSELL

A CASSELL BOOK

First published
1993 by Cassell
Villiers House
41/47 Strand
London
WC2N 5JE

Distributed in the United States
by Sterling Publishing Co., Inc.
387 Park Avenue South, New York
NY 10016-8810

Distributed in Australia
by Capricorn Link (Australia) Pty Ltd
P.O. Box 665, Lane Cove, NSW 2066

British Library Cataloguing-in-Publication Data
A catalogue record for this book is available from
the British Library

ISBN 0-304-34333-1

Typeset by MS Filmsetting Limited, Frome
Somerset
Printed and bound in
Spain by Gráficas Reunidas, S.A.

CONTENTS

Acknowledgements 7
Author's Note 7
Introduction 9

1 BASIC DEVELOPING AND
PRINTING TECHNIQUES 12
Control of Grain and Contrast 12
Burning and Dodging 25

2 COMBINING IMAGES 30
Superimpositions 30
Sandwiches 33
Montage 45

3 INTRODUCING COLOURS 56
Toning 57
Tinting 60
Etch Bleach 63

4 LITH FILM 68
Line Conversion or Bas-relief 72
Tone Line 73
Lith Masks for Colour
Transparencies 75
Solarization (The Sabattier Effect) 80
Tone Separation or Posterization 82

5 EXPLORING OLD
PROCESSES 86
Paper Negatives 87
Bromoil 92
Gum Bichromate 96

6 CREATIVE MOUNTING 102
Multiple Mounting 103
Sympathetic Surroundings 107
Interactive Mounting 112

7 PRACTICAL APPLICATIONS 122
Christmas Cards 122
Marquetry 126
Games 129
Clocks 130

8 EXPLORING OTHER
CREATIVE SOURCES 134
Photocopier Art 134
Pinhole Cameras 138
Printed Circuit Board 139
Crystals in the Developer 141
Mirror Images 142

Postscript 145
Technical Details 146
Checklist of Equipment
and Materials 148
Bibliography 154
Index 155

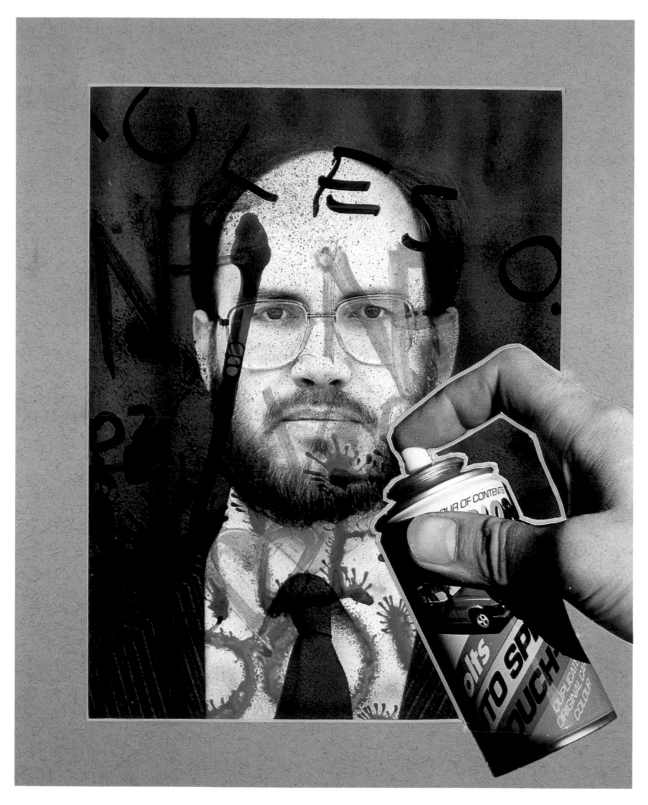

Self Portrait with Graffiti

ACKNOWLEDGEMENTS

During the time it has taken to write this book, several close friends and colleagues have given invaluable feedback both on the pictures and on the text, or have helped in other ways. Some of their suggestions generated further ideas for pictures, some of which have been executed and included.

To the following people, therefore, I offer my grateful thanks and hope they enjoyed making their contribution to the book as much as I valued receiving it: Samantha Arthur, Chris Howes FRPS, Arthur Howlett LRPS, Celia McTaggart, Brian Steptoe FRPS and Ian Wheatley.

I must acknowledge also the artistic opinions of my wife, Sue Wainwright LRPS, which have been invaluable when I have been unsure whether a picture has worked. Our Christmas cards are a joint effort and half the credit is due to Sue.

Finally, this book may never have been completed at all had it not been for the moral support and encouragement which I received from far too many people to mention by name.

AUTHOR'S NOTE

Throughout this book I have mentioned specific manufacturers of materials where a particular brand is important to achieve a certain effect. In other places I have stated what materials were used, purely because this information may be of interest to the reader. In many cases equivalent results may well have been achieved using other brands; life is too short to try them all. The absence of any mention of particular materials or manufacturers therefore, should not be taken to suggest they are unsuitable.

Creative Darkroom Handbook offers several formulae for making up your own solutions. When mixing the chemicals, add them to warm water, in the order given, stirring well to ensure each is fully dissolved before adding the next, and then dilute to the required volume with cold water. Please assume that all chemicals are toxic. Use them with extreme care, avoiding contact with any part of the body, including the skin, and particularly with sensitive membranes such as the eyes. Wash your hands thoroughly after handling them. Don't allow such warnings to spoil your enjoyment of photography – given suitable precautions, all the chemicals mentioned are perfectly safe to handle.

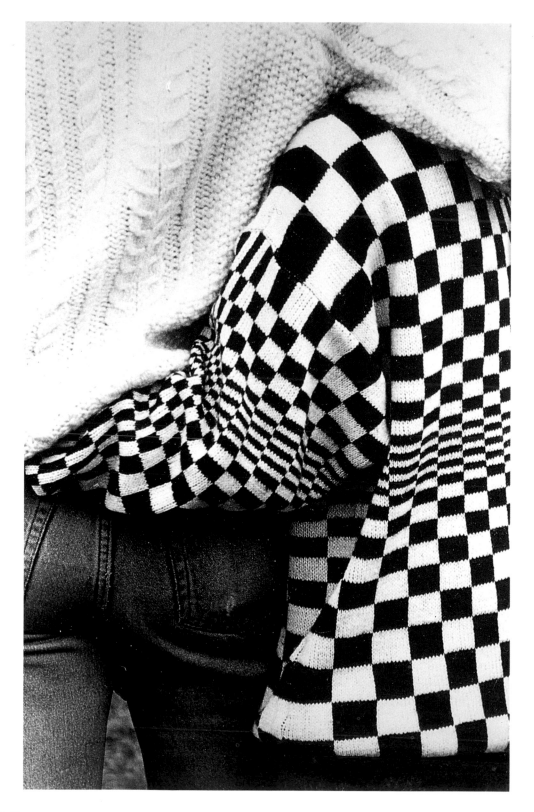

Check Mate

INTRODUCTION

Creative Darkroom Handbook is a book of photographs, all of which were made for the exhibition wall. The pictures have one thing in common: they have all been consciously manipulated away from the scene the camera originally saw, using a variety of means. The purpose of this book is primarily to encourage your own original thinking and to provide a stimulus for new ideas. You will probably learn some new creative techniques as well.

Manipulated images are not necessarily complicated and they don't always need a darkroom. Many of the pictures included in this book could have been made by any photographer with only the minimum of equipment. The starting point can be a black and white negative, a colour transparency or a colour print. It is even possible to produce imaginative photographic images starting from totally non-photographic origins.

There is no doubt that a reasonably well-equipped darkroom is useful and you will certainly need one if you wish to explore all the special effects described in this book. However, a basic knowledge of printing is all that is required to start with, because you will soon be experimenting and learning new technical skills as your creative ideas develop.

The choice of starting material – black and white or colour – is entirely personal, and

depends on the desired effect. Colour is a much more realistic medium than black and white, for the simple reason that the world is itself colourful. It follows, therefore, that any mono-chrome representation of the world is already a step removed from the truth, and this makes it a much more exciting medium to use in creative photography. For this reason, you will find that most of the photographs in this book origi-nated from black and white film stock.

A creative photograph requires both an idea and a technique, but it is the idea – that spark of imagination in the photographer's mind – that starts the process rolling. All too often, photo-graphers discover a new technique and then try to think of a suitable picture on which to use it, but this is the wrong way round. A technically excellent photograph without a purpose is very likely to be boring to the viewer. It is far better to start with an imaginative idea and then decide how best to execute it – choosing from the full range of techniques available, and adapting and combining them as necessary to produce the desired result.

Trying out new materials and methods is an important part of our learning process as photographers. Familiarity with a wide variety of techniques helps us to develop the full potential of our creative ideas. However, an uninteresting negative treated in an unusual way does not automatically mean a good

picture. On the other hand, careful choice of treatment can very often enhance the right negative or transparency. It is also possible to salvage a technically poor original by judicious use of photographic methods, provided the basic material for an imaginative image exists in the first place.

Many books have been specifically written about creative techniques in photography. By and large, they are concerned more with methods than with pictures. They have an invaluable role to play in teaching the basic techniques necessary to execute even masterpieces, provided there is the seed of an idea in the photographer's mind.

Individual photographic techniques are no more than basic raw materials, which can be used alone, combined, modified or developed as necessary to execute a specific idea. There are no rules. Whatever means you can find of achieving the end result is valid and acceptable. All that matters is to produce a good picture; to transform the mind's image into something that can be shared with and be appreciated by the viewer.

Some traditional photographers take the view that all photographs must use only 'pure' photographic methods and that anything else is cheating. The use of non-photographic elements, such as hand-colouring, is taboo in their minds. If ever there was a way of inhibiting original and imaginative thinking, this must surely be it. Picture-making is what matters, and that involves using whatever materials and methods are available, photographic or not. If, somewhere along the line, the non-photographic element exceeds or even replaces the photographic element, so what? There is no penalty for crossing the conventional bounds of photography. There is nothing magical about a camera that we must spend the rest of our lives restricted to peering through its little rectangular viewfinder.

Creative Darkroom Handbook is a book of photographic ideas. It does not set out to be yet another textbook of photographic techniques. For every exhibition picture shown in the book, there is a full account of how it was made. There are no secrets; to reveal the process is to describe a means to an end, but there has to be an idea in the first place for the process to be useful. The purpose of this book is to inspire photographers to broaden their approach to picture-making, to explore and perhaps even exceed the boundaries of normal photographic methods. It is ideas that make pictures, but the generation of an idea needs a stimulus, a good imagination and a receptive mind.

Use this book to stimulate some ideas for original pictures. Try out some of the techniques, and then think of others which aren't described here. Try not to copy, but think for yourself. Experiment and adapt the techniques you like best for your own purposes, so that you develop a style of your own. Above all, enjoy it!

HOW TO BE CREATIVE

Only two things are needed to make creative photographs, and imagination is the most important of them. The other thing you need is a loaded camera, but everyone has a camera, and they're all good enough for the job, so let's forget all about cameras and concentrate on the intellectual aspects of photography: the seeing, the thinking, the planning, the ideas, without which a camera is a random instrument.

This is all the advice you need to get the most out of your photography but, having said that, generating ideas is easier said than done. They certainly don't come to order. So what do you need to do to influence this creative process, which always seems to give the best ideas to someone else?

First you have to expose yourself to creative stimuli and allow your mind to become receptive to new ideas. Study the work of other

photographers, artists, sculptors – particularly that of the great masters in their field; look at pictures and fill your head with examples of successful images. Use them to generate ideas of your own, rather than copying them. Inspiration may come from viewing familiar subjects in different and unusual ways; exploring them from odd angles, looking at them in terms of shapes, tones or patterns, allowing yourself to ignore the obvious identity of the subject. Don't just do this when you have a camera round your neck, but train yourself to see and think like this all the time. The ideas will then come of their own accord, but probably when you least expect them, and when it is least convenient to do anything about them. Jot them down in a notebook, however daft they might seem, because later on, when you are not in the bath, you may think of a way of executing them.

Thinking of an idea and executing it involve two quite distinct states of mind, and it is wise not to try to do the whole job at once. Allow time to consider the ideas and perhaps experiment with some practical photographic techniques, before trying to produce a final piece of work. Technical skills in photography are easily learnt, and your ability will develop rapidly as you use them.

There is a fundamental difference between the camera lens and the human eye. The camera simply records an image of what it sees. It does not know what it sees and cannot interpret the subject; it just records in terms of shape, tone, colour and perspective everything within its field of view. By contrast, it is difficult for the human eye to do this, because it is always influenced by a degree of understanding of what it sees. The mind is constantly interpreting, stylizing, analysing, exaggerating and extracting meaning. Herein lies the secret of creative photography, which is concerned with recreating in a permanent form all these interpretive aspects of the simplistic view as seen by the camera.

The objective is to distil the spirit of an idea. The camera lens is undiscerning, and records everything it sees. This is usually more than is recognized by the eye, which selects out the essence of the picture and ignores what is not relevant. We do this unconsciously and, therefore, when we view a picture we do not always recognize the superfluous material recorded by the camera, because the eye makes the same selective interpretation. However, we can train ourselves to simplify our pictures, so that we lose detail irrelevant to the point we wish to make. This can be done either at the point of taking the photograph, for example by changing the angle of view, or by improving the lighting, or we can do it in the darkroom afterwards, using creative techniques such as those described in this book.

Simplifying an image is a perfectly legitimate means of enhancing the message, but by its very nature it involves a loss of information from the original scene. Since most modern cameras and lenses are designed to produce an image of ultimate technical quality, it follows that losing information is the same thing as losing quality – *technical* quality. Quality, however, is a measure of the ability of something to perform a certain job well. Technical quality concerns the camera's ability to record in accurate detail everything it sees, which, at best, is only a part of picture-making and can sometimes be almost irrelevant. What we are interested in here is the overall quality of the finished piece of work, which includes quality of seeing and quality of craftsmanship, as well as pure technical quality. If a picture is successfully enhanced by a lack of sharpness or by a grainy effect, say, because it produces a 'dreamy' effect, then the overall quality is good, even though the technical quality, as defined by the camera manufacturer, may be considered poor. It is important to recognize this point, and not to be hidebound into thinking that 'sharp and detailed' equals good quality. Sometimes it does, but not always.

BASIC DEVELOPING AND PRINTING TECHNIQUES

In its very simplest form, making a black and white print is just a matter of exposing a negative on to a sheet of printing paper and then developing it. All that is needed is a darkroom, or indeed any darkened room, containing a very basic set of equipment: an enlarger, developing dishes, measures, a safelight and the necessary chemicals. Anyone who has access to this equipment, and knows in general terms what to do with it, or has a book of instructions, is able to produce a straight print.

It is perfectly possible to produce an excellent quality print in this way, but it is very unlikely that you will be getting the most out of your negative unless you exercise some printing 'control'. Very few negatives give the best possible print when printed straight.

Even before the printing stage some creativity can be exercised by careful thought about how the film should be processed. The speed at which the film is rated, the temperature at which it is developed and the particular developer used all make important contributions towards the final effect.

In creative terms, therefore, an image can be extensively manipulated using nothing more than basic developing and printing skills, without introducing any specific derivative techniques. This chapter looks at ways of controlling the final printed image.

CONTROL OF GRAIN AND CONTRAST

Before starting to look at ways in which grain and contrast can be manipulated in a photographic image, it is worth appreciating just why it is that different emulsions have different grain and contrast characteristics, and how the two are related.

Photographic emulsions are composed of light sensitive silver halides, which are evenly distributed in gelatin and coated on the film or paper backing. The silver halide is insoluble in the gelatin and is present in finely divided particles or grains. It is the reaction between these silver halide grains and the developer to produce metallic silver which produces the black image of a monochrome photograph. It also explains why the image has a granular quality when viewed closely. The subject is complex, but this simplistic description is adequate for our purposes.

The sensitivity of a photographic emulsion – usually referred to as its speed – is dependent upon the size of the silver halide grains it contains. Fast films contain large grains, and are more sensitive than slow films, which contain smaller grains. This is why fast films, such as ISO 1000, appear much more grainy than slow ones, such as ISO 25.

During development the silver grains have a

tendency to clump together. This gives an increase in graininess, which can be detrimental to the image. Manufacturers minimize the problem by producing fine grain developers which retain the maximum image detail.

The choice of developer and the degree of development are two very important considerations in deciding how to process a particular emulsion. The choice will determine not only the grain size of the image, but also its contrast – the scale of tones in the image – which is closely related. In general, fine grain developers give relatively low contrast, whereas high speed (and hence coarse grain) developers give higher contrast. With any developer, the general rule is that the longer the development time, the higher the contrast.

Thus grain, contrast and film speed are closely interrelated, with an increase in one associated with an increase in the others.

Manufacturers of photographic materials assume that photographers want the best possible technical quality in their images, to ensure that the finest detail can be recorded. This means fine grain, high resolution and a contrast range similar to that which occurs naturally in outdoor scenes. Photography is, after all, a recording medium. Such high quality can only be achieved at the expense of film speed though, which is why the best recording films have a speed of ISO 25 or lower. The long exposures which become necessary with slow films, and the use of a tripod, are not always practical, however, so manufacturers design their materials to have optimum properties: the finest possible grain, and most acceptable contrast range, for a film speed which is practical for general use. Thus most films represent a compromise from what is possible.

Advances in photographic science are constantly being made, but these are always towards finer grain, better resolution and a more natural contrast range. Flat grain technology has resulted in films such as Kodak T-Max and Ilford Delta, which have a grain structure more typical of much slower films, thanks to the use of flat, tablet-shaped grains, with a greater surface area. Likewise, chromogenic films such as Ilford XP2, which rely on colour-processing chemistry, give exceptionally sharp results.

Modern films and paper can, therefore, be relied upon to give as true a reproduction of the original scene as possible, provided they are exposed and processed as recommended.

In most cases this is what we, as photographers, expect of our materials, but sometimes, for creative reasons, the high technical quality of the materials we use can be a positive disadvantage. Grain and contrast are an integral part of the photographic process, and they can often be abused with good effect to create a particular mood or atmosphere. Do not feel reluctant to enhance either of them if doing so improves your photographs. In the same way that manufacturers' instructions are intended to give realistic images, disobeying the instructions is a good starting point if you wish to deviate from reality.

To enhance grain or contrast is strictly to reduce technical quality. Grainy or contrasty photographs are often criticized as 'poor quality', but do not confuse 'pictorial quality' with 'technical quality'. If the technique is successful in pictorial terms then the picture is of 'good quality', and the purely technical aspects are of secondary importance.

Photographers who wish to exploit the extremes of film speed, grain size or contrast range are in a minority and often find that available materials are not suited to their purpose. For example, what manufacturer ever specifically designed a film with huge grain, despite there being so many pictorial uses for such a film? The creative photographer, therefore, has to seek alternative ways of producing the results he wants, and the first step is to throw away the instruction leaflet.

There are several ways of enhancing grain and contrast, both at the film processing stage

and during printing. For really dramatic effects, more than one technique can be used. The methods I have found to be most useful are described below.

Hard Paper Grades

Most readers will know that photographic paper comes in a range of different contrast grades, typically numbered from 0 or 1 (soft) to 4, 5, or even 6 (hard). The most obvious way of increasing contrast during printing is, therefore, to use a harder grade of paper. The extreme grades are often difficult to obtain, and you could be excused for believing that only Grades 2, 3 and 4 exist, as these are far and away the most commonly sold.

Particularly hard grades of paper, which are worth trying to obtain for a very high contrast result, include Agfa Brovira Grade 5 (sadly, the Grade 6 they used to make is no longer available) and Sterling Grade 5 (imported from India).

Variable contrast papers such as Ilford Multigrade and Kodak Polycontrast are popular because they avoid the need to stock several packs of paper of different grades. Simply filtering the light from the enlarger enables such papers to produce different contrast ranges: magenta filters are used for hard paper grades, and yellow filters are used for soft paper grades. Variable contrast papers are equally applicable for the techniques described below, although it may prove more difficult to achieve a particularly hard image.

The advantage of controlling contrast by means of paper grade is that the negative is not affected, and can be used to make a print of normal contrast if necessary. On the other hand, the degree of extra contrast possible, using paper grades alone, is relatively small. For more dramatic effects it is necessary to resort to other means, such as 'push' processing, copying, paper negatives or even, for extreme contrast, lith film. These techniques are all described later in this book.

Hard grades of paper are used predominantly to give a high contrast print, rather than to produce a grainy result. Whilst a slight increase in grain size is usually apparent when hard paper is used, there are better ways of achieving a really grainy picture (see Push Processing and Texture Screens on pages 19 and 40).

The original scene (*opposite*) As it was misty, the natural contrast range was low. A print made on Grade 3 paper looks dull and grey.

Steep Holm from Sully Island (*below*) Simply making a straight print on Agfa Brovira Grade 6 paper, now sadly no longer available, produces a high contrast image.

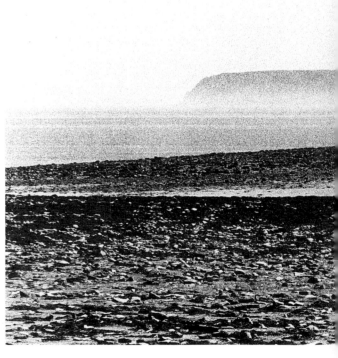

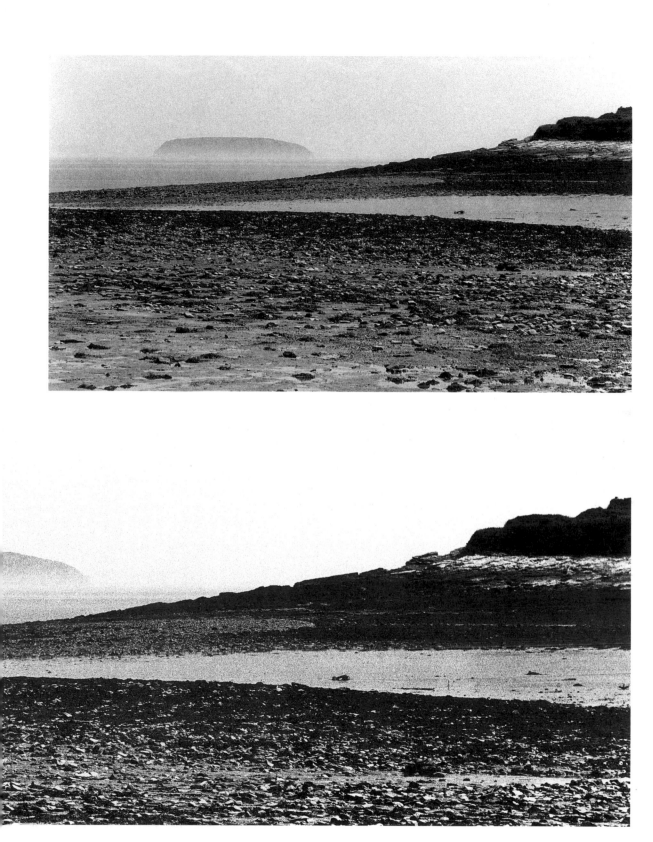

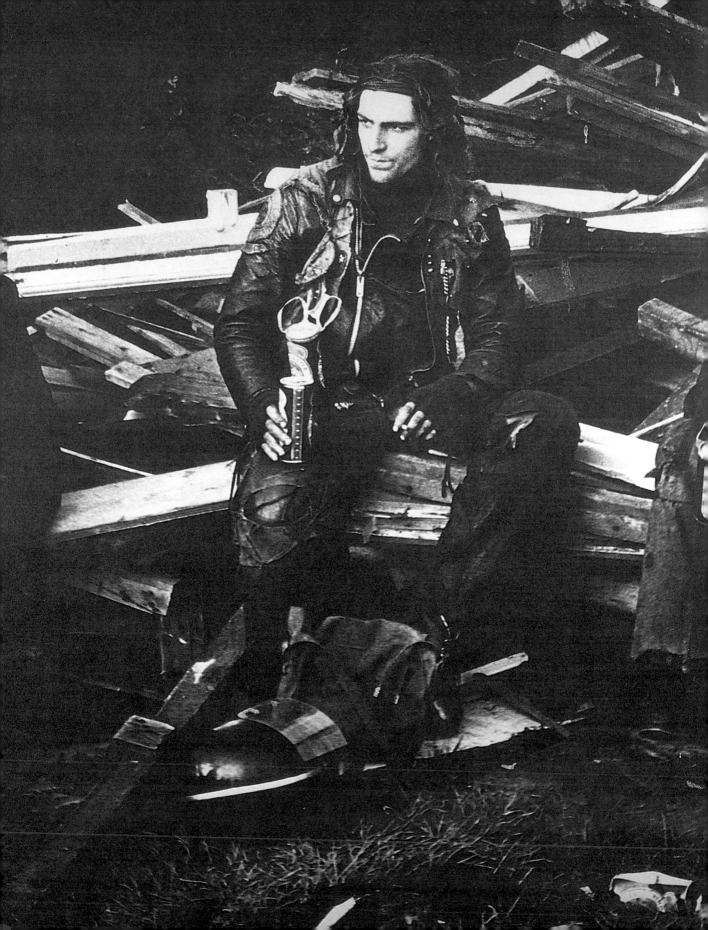

The straight print

Angel from Hell The event was a rally of motor-cyclists, gathered to protest about the compulsory wearing of crash helmets. The negative was under-exposed, necessitating a hard paper grade to produce an acceptable print. Printing on Ilfobrom Grade 5 (now no longer available) gave a harsh 'gritty' effect, which suited the subject. The print has also had some selective 'burning' to darken the surroundings (see Burning and Dodging on page 25).

Changing the Developer

Sometimes even Grade 5 paper is not hard enough for a particular negative. If ever you find you need half a grade – or a grade – more contrast than the paper provides, a useful trick is to increase the concentration of your developer. If the recommended dilution for the developer you use is 1 to 4, and the hardest grade of paper available doesn't quite give the degree of contrast you want, add an extra one part of developer concentrate to the working solution in your developing dish. If necessary, add another shot of developer and keep going until you are happy with the result. If all else fails, you can always use concentrated developer straight from the bottle.

This technique is useful for relatively subtle changes in contrast, but is unlikely to be useful if you expect to see a dramatic change. It also works in reverse: diluting the developer with aliquots of water produces a subtle decrease in

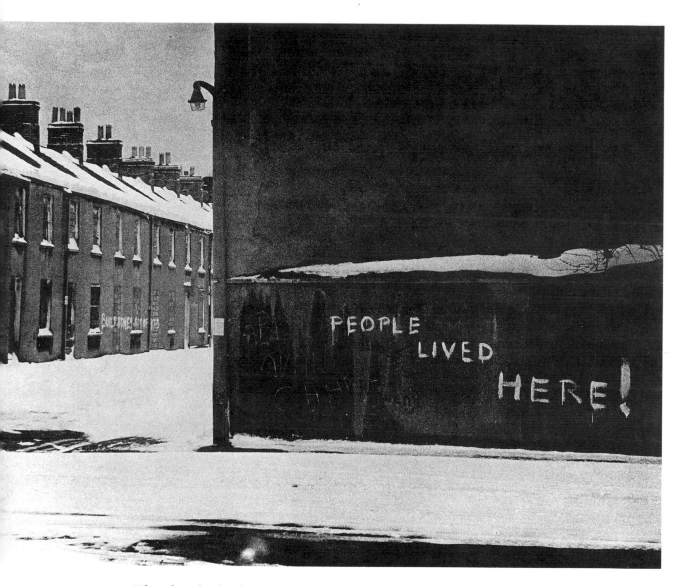

contrast. The drawback, however, is that, unless you are prepared to use fresh developer for each print, all subsequent prints receive the same treatment.

Taking this technique one stage further, the print can be developed in lith developer. This extreme contrast developer is designed for use with lithographic film, a medium used in the graphic arts industry (see Chapter Four – Lith film). Lith developer is not intended for use with bromide paper. Nevertheless, it produces a much harder image than a conventional

Ghost Town These houses in Cardiff had been bricked up, pending demolition to make way for more offices. The occupants had been evicted. The statement 'People Lived Here' is strangely poignant and says it all. The most suitable printing style for this picture is one which emphasizes the harshness and hostility of the scene. Therefore, the final print was developed in lith developer to give extreme contrast.

A normally printed version Printed on Grade 3 paper, the picture is relatively mundane.

bromide developer, although the image colour is likely to be rather brownish. The working life of lith developer is a matter of only two or three hours, and it soon becomes a black sludge. So it is advisable to make it up freshly when required.

Push Processing

One of the most effective ways of increasing both contrast and grain is to push process the film. Push processing involves uprating – underexposing – the film and then over-developing it. For example, if an ISO 400 film is uprated to ISO 1000, the negatives are underexposed. If processed normally, they appear thin and lacking in contrast. By overdeveloping the film, however, the density of the negatives can be corrected, but there is an increase in both contrast and grain. The greater the over-development, the greater will be the effect on both contrast and grain.

Up to a point, grain size can be controlled by adjusting the temperature at which the film is developed. The higher the temperature, the larger the grain on the image. If you want a grainy result, but developing at 20°C gives relatively fine grained negatives, try developing the next film at 25°C or 30°C – reducing the development time as necessary to give the same overall degree of development. Temperature/time conversion tables or graphs are usually given in the developer instructions, but you will have to extrapolate for the higher temperatures.

Don't use too high a temperature for film processing, or reticulation may occur. Reticulation is a form of distortion of the emulsion caused by clumping of the grain particles into chains. It gives a wrinkled appearance and is irreversible. It is far better to use this effect in a controlled, intentional way, than to find accidentally that your negatives have become 'creative'!

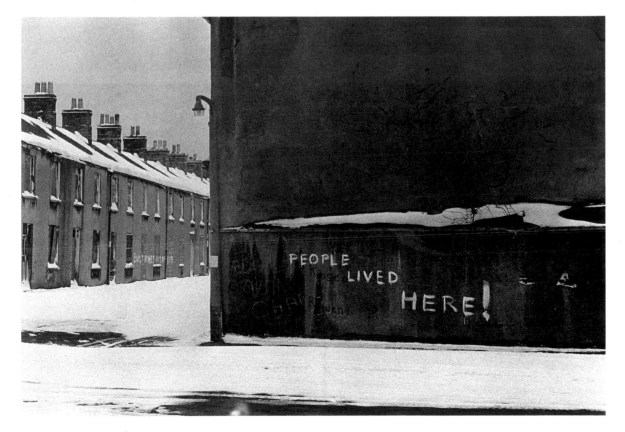

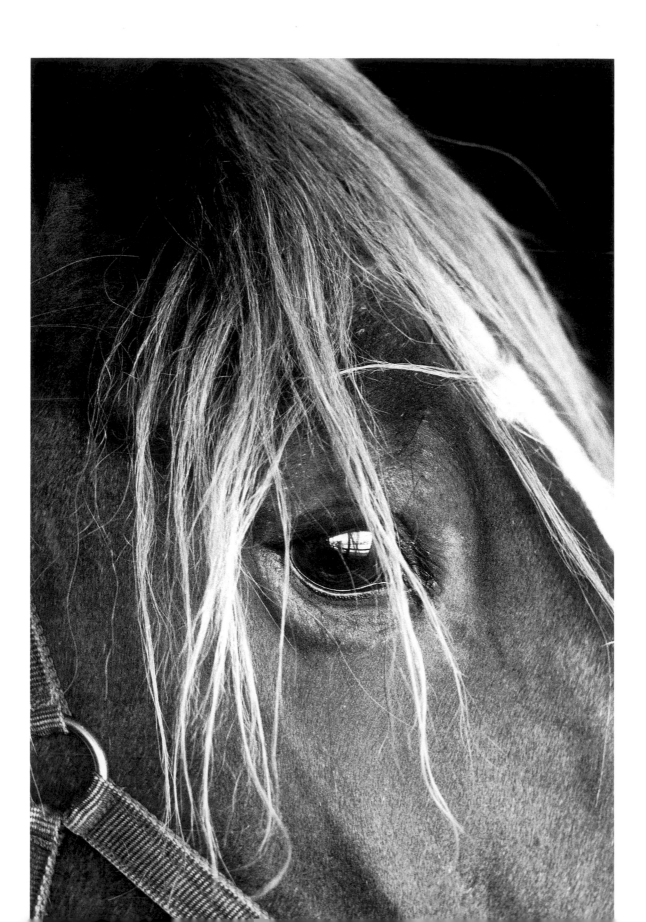

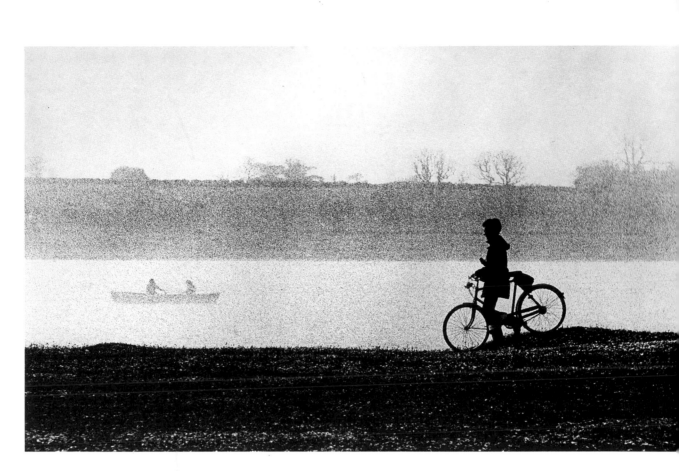

To increase the contrast of a negative without significant grain enhancement, push processing is best done at a temperature as near to 20°C as possible.

Over the years, I have evolved a technique based on push processing principles which I now use for all my films, because it gives very 'punchy' negatives with sufficient contrast and grain to suit the subjects I photograph. This is achieved with Ilford FP4 film and Paterson Acutol developer, for which the respective manufacturers recommend a speed rating of ISO 125 and a developing time of six minutes at 20°C. These recommendations are fine for a

Daphne Push processing can, if necessary, be used to increase contrast without an adverse effect on grain size. The technique used for this print is identical to that used for *By the Mere*, except that a temperature of only 22°C was used.

By the Mere This is an early morning shot, taken before the mist had cleared from Hornsea Mere. Both the contrast and the grain size have been enhanced by uprating the ISO 125 film (Ilford FP4) to ISO 400 and overdeveloping the negative (20 minutes in Acutol) at a high temperature (about 28°C).

standard photograph where a third of the view is sky and the sun is shining. However, given an overcast day with overall low contrast – conditions in which I prefer to work – the recommended technique produces negatives which lack sparkle. I therefore use FP4 rated at ISO 400 and develop it for 20 minutes at 20°C. The developer is used at the recommended dilution of 1 + 10. This degree of overdevelopment is unlikely to suit every photographer's needs, and you should experiment to find the optimum development time for your own photographs.

Colour Magazine

The Young and the Old This print was produced by a combination of push processing and a hard paper grade. The film was Ilford HP3 (ISO 400), incidentally about ten years out of date at the time, uprated two stops to ISO 1600 and developed in Acutol. The print was made on Sterling Grade 5 paper.

Dawn Flight The same time and place as *By the Mere*, but looking further into the mist. A straight print lacks contrast and is grey when printed even on Agfa Grade 6 paper. The print was, therefore, rephotographed on FP4, uprated to ISO 400 and overdeveloped at a higher temperature than recommended. The result is a punchy picture with dramatic grain.

Copying

Copying anything, whether a print or a negative, always leads to an increase in contrast, which can sometimes be equivalent to several grades of paper. Thus copying can be used specifically for increasing contrast.

First, print the negative on the hardest grade of paper available. Use Grade 5 or 6 if possible. If the print has insufficient contrast for the effect you want, copy it. The easiest way to do this is to set up your camera on a tripod and simply rephotograph the print. Take care to light the print evenly and avoid reflections.

The choice of film with which to copy your print is up to you. Specific copying films are available, but these are generally designed to minimize changes in contrast and grain. It may, therefore, be more appropriate to use a film not

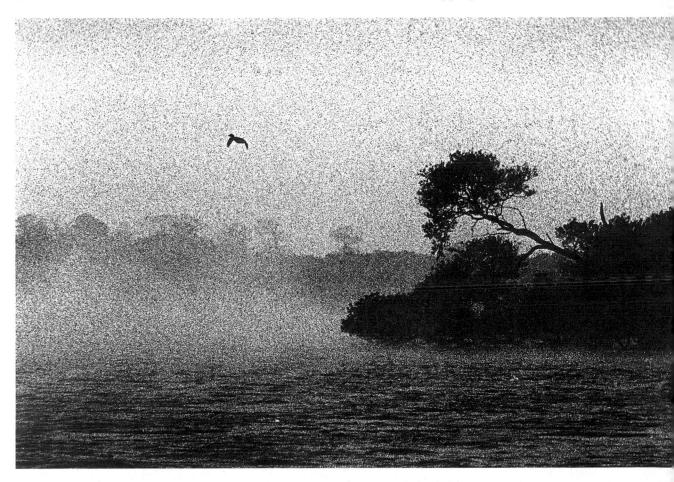

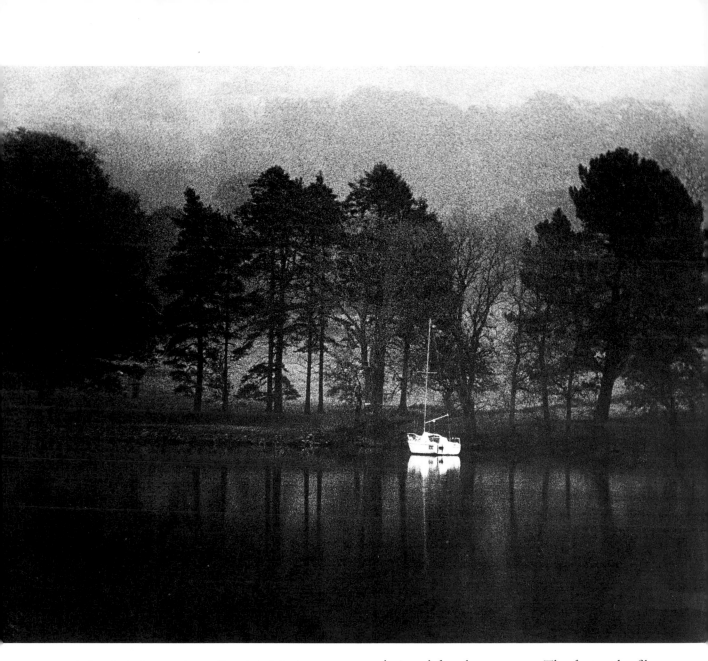

Lakeside A picture taken at five o'clock in the morning on Lake Windermere in the Lake District – in the dark! My objective was to take a photograph in the minimum possible amount of light. Logically, if I could see the subject there must be enough light to produce an image on the film, given a long enough exposure. The exposure for this picture was several minutes, with the lens set at full aperture. The camera was mounted on a tripod. There is the merest hint of an image on the original negative, and the print was copied as described on page 23. The result is unrealistic and gives an enchanted feel to the scene.

designed for the purpose. The faster the film you use, the grainier the result will be. Using ISO 400 film, or even ISO 1000, gives some interesting effects.

Why not push process the film used for copying? This can produce dramatic effects. The grain on the original print is augmented by even larger grain in the emulsion of the copying film, so even the grain becomes grainy.

If the copy print is still not to your liking,

copy it again. There is no limit to the number of times the process can be repeated. However, bear in mind that, whilst contrast and grain both increase at each copying stage, the sharpness of the image decreases. There comes a point, therefore, where the overall quality of the photographic image becomes unacceptably degraded.

Extreme Contrast Film

The most drastic increases in contrast are produced by copying a negative on to extreme contrast film, such as lith film. All intermediate grey tones are eliminated, leaving an image in stark blacks and whites only. Lith film has so many creative applications that the whole of Chapter Four is devoted to the subject.

BURNING AND DODGING

However skilful a printer you may be, if you simply expose a negative on to the paper and then develop it, you are almost certainly not getting the most out of your negative. The negative merely records, in terms of tones, the original scene; the highlights and shadows remain just where they were at the time. This is fine if the lighting conditions were absolutely perfect when the photograph was taken. In nearly all cases, though, the lighting, or the distribution of tones can be improved. This is why it is useful to have some means of manipulating the tones in the print.

Burning *(left)* **and dodging** *(right)*

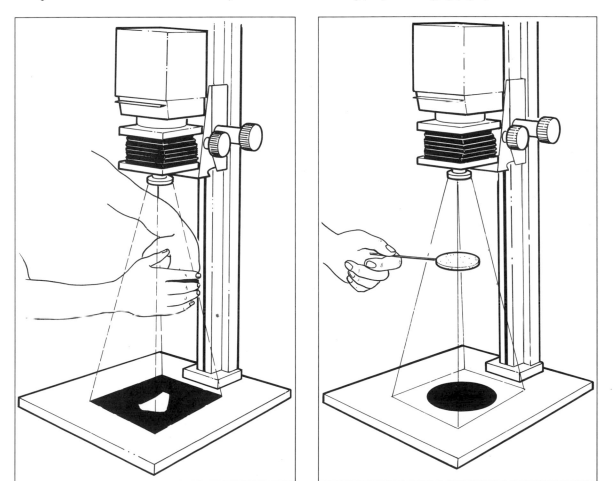

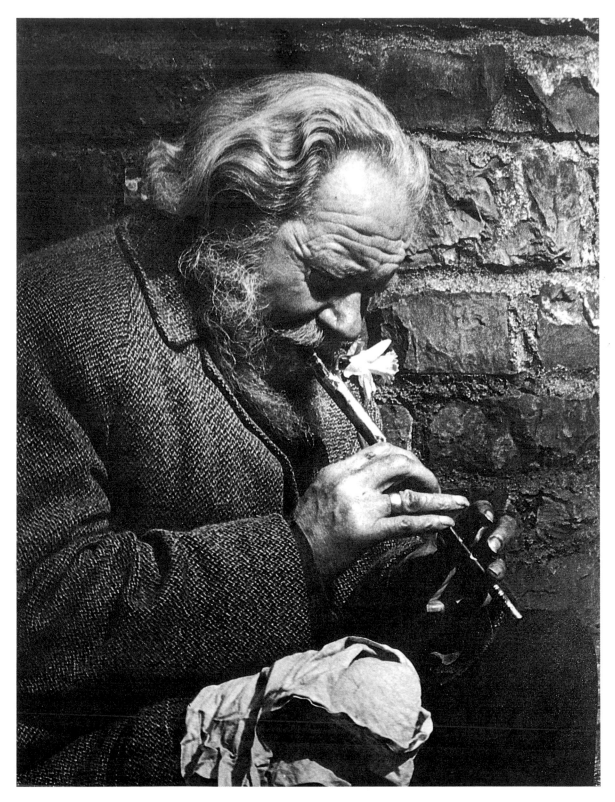

A Threepenny Opera This print was made by selective enlargement and using burning and dodging techniques. The intention was to concentrate attention on the face.

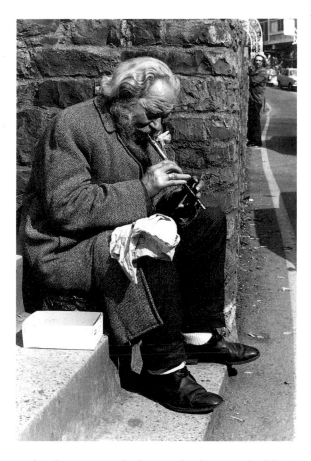

The unmanipulated print (*right*) was distracting because there was too much emphasis on irrelevant features such as the box, the handkerchief, the white socks and the man with the dog.

During enlargement, the density of each tone in the negative is what controls the amount of light falling on the paper, and this determines the distribution of tones in the print. If the amount of light falling on to the paper is artificially changed in one area of the negative, but not another, the distribution of tones in the print can be altered. This can be achieved by placing objects in the light beam from the enlarger during the exposure, so that they cast shadows on the paper.

Increasing the exposure to a specific area of the print is known as burning or burning in. It has the effect of darkening that area of the print. The simplest way to do this is to hold a piece of card, with a hole cut in it corresponding to the shape of the area to be burnt, in the light beam from the enlarger.

Reducing the exposure lightens the print,

and is known as dodging, shading, or holding back. A piece of card, known as a dodger, is cut to the shape of the area to be dodged, and is held in the light beam. Attaching a piece of thin, but rigid, wire to the dodger allows it to be positioned anywhere within the light beam. Being thin, the wire itself leaves an insignificant shadow on the paper.

A more flexible means of burning and dodging, but one which requires more skill, is to use your hands instead of pieces of card. Hands have the advantage that the shape of the shadow can be constantly varied, to allow the edges of the area being controlled to diffuse and blend with the natural tones in the print. It is rather like making shadow puppets.

Whether you use pieces of card or your hands, the procedure is the same: the shapes are held in the enlarger light beam to restrict the

light to the specific areas where exposure is required. The shapes are held rigidly if distinct shading is required, or they can be moved to and fro to create a more subtle and diffuse shading which blends into the print. The ultimate objective is for burning and dodging not to be obvious in the final print.

It is always easier to make a straight print than to 'fiddle around' waving things about in the enlarger beam. Nevertheless, burning and dodging techniques are well worth practising if you want to get the best out of your negatives. Nearly all prints will benefit, to some extent, from a degree of localized tone control.

Once you start to gain some expertise in printing control, you will soon find you have lots of previously 'unprintable' negatives that you can now print. If the lighting was dull when the photograph was taken, it no longer matters, because you can create highlights and shadows in the darkroom. For that reason it is often better to take photographs in overcast, rather than sunny, conditions. If the sun shines you have to accept the highlights wherever they happen to be. If it is dull you can add the highlights where you like by manipulation in the darkroom afterwards.

Conspirators I spent 20 minutes waving my hands in the enlarger beam to produce this picture. The three people in the crowd at Speakers' Corner in London were not necessarily even together, but by coincidence their expressions were complementary. The picture was printed to emphasize the implied conspiracy.

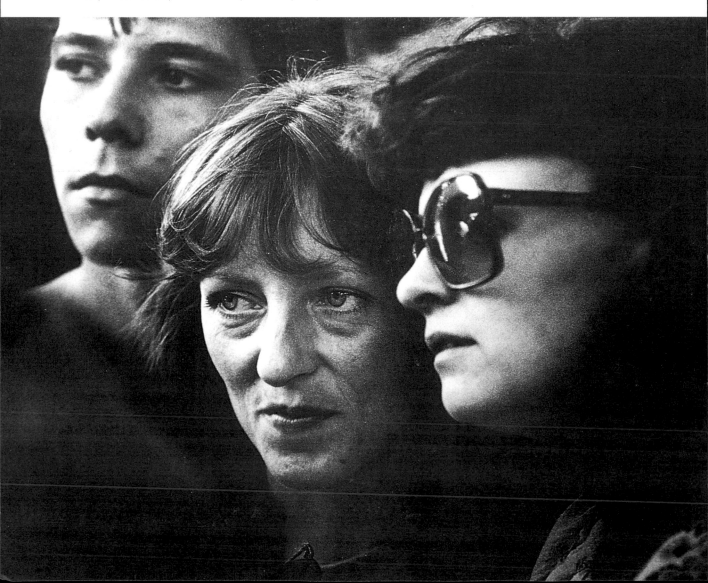

If you use variable contrast paper, burning and dodging techniques have an added advantage in that different areas can be exposed through different filters. This means that you can vary the contrast range in individual areas within a single print.

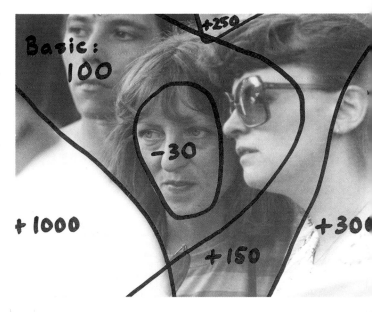

The unmanipulated print (*below*) lacks visual cohesion between the three people and is tonally messy.

The diagram (*right*) shows the different exposures given to various parts of the print to achieve the desired effect. The basic exposure for a 20 × 16 in (50·8 × 40·6 cm) print was 100 seconds at f8. The centre face was dodged for 30 seconds of this exposure. The other areas marked on the diagram were given additional exposure for the times indicated.

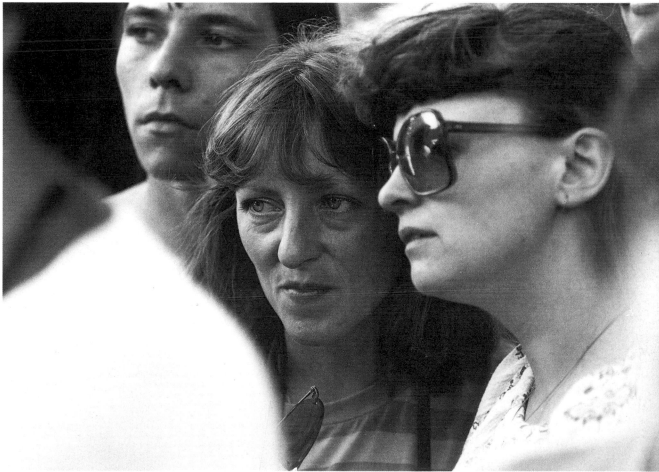

Combining Images

Having shown how easy it is to manipulate a print made from a single negative, let us now think about ways of combining two or more images.

First of all, why should we need to combine more than one image? Isn't it better to wait until the conditions are such that a straight photograph can be taken? This would certainly be true if the intended picture could be produced as a single image. Indeed, combining one image with another should not be seen as a means of improving the original. Rather, the main purpose of combining images is to produce improbable photographs; pictures where elements come together which could never have been juxtaposed for a straight picture.

There are three fundamental ways of combining images – superimpositions, sandwiches and montages. Superimpositions involve exposing two or more different images on to a single frame. They can be made in the camera or at the enlarging stage. Sandwiches involve a single exposure only, made through two or more negatives or transparencies bound together in register. They can be printed or projected. Montages are made by cutting up two or more prints, from different negatives, and then pasting the pieces together to achieve a composite result.

Each of these techniques can be used alone, or they can be combined. The component parts of a combined image can be monochrome, colour or a mixture of both. The starting point can be a negative, a transparency or both. Any number of component images can be brought together in the final picture. There is no limit to the number of possibilities and surreal results are possible.

SUPERIMPOSITIONS

Multiple Exposures in the Camera

The most obvious way of combining images is the one we have all suffered from unintentionally: superimposed images caused by forgetting to advance the film. Camera manufacturers have now largely ironed out this 'problem' by producing cameras which are incapable of multiple exposures. This is a great advance in camera technology, but it does pose difficulties when deliberate multiple exposures are required. Thankfully, some cameras, although mostly the expensive ones, have a multiple exposure facility which allows the shutter to be cocked without advancing the film. If your camera doesn't feature this facility, you should be able to make the first exposure, then gently wind on the film while holding the rewind crank so that it can't move. This has the effect of cocking the shutter, without advancing the film.

Multiple exposures in the camera are a

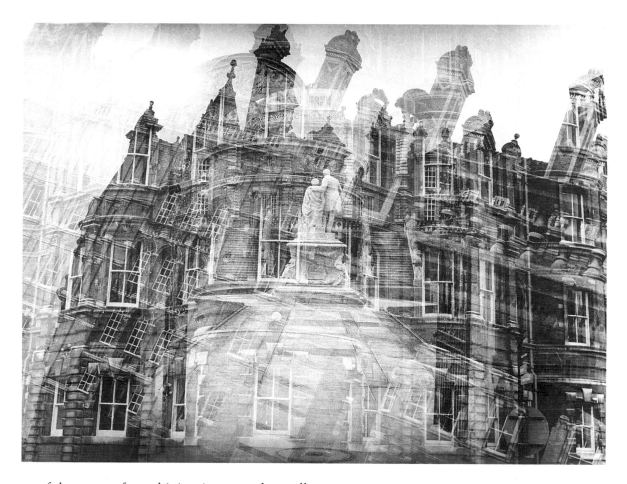

useful means of combining images where all the component parts can be shot together. It is more difficult to combine images taken a long distance apart or over a long period of time, because the film must be left in the camera between shots. An additional disadvantage is that there is no margin of error. The results are not seen until the film is developed. By that time it may well be too late to repeat the picture, unless the component parts are exactly as you left them.

Making multiple exposures in the camera is simple: just take one exposure after another without advancing the film. Take care to reduce each individual exposure so that the total exposure is correct for the film speed used. If you are using negative film, don't forget that the tones are reversed: a bright sky produces a

Royal Holloway College The Royal Holloway College, now part of the University of London, is an elaborate Victorian building. Here, four separate exposures were made on the same frame of film to draw further attention to its intricate details.

dark tone on the negative and any superimposed image will be hard to see in this area. This technique is, therefore, useful for superimposing a light subject on a dark background.

Ensuring that individual images are correctly positioned within the frame is easy with large and medium format cameras and with those 35 mm cameras where the pentaprism can be removed to give access to the focusing screen. With these cameras a piece of tracing paper is placed over the focusing screen, and an outline of each image can then be traced to aid

registration. With 35 mm cameras with a fixed pentaprism, aligning the individual images is more difficult, because it must be done by memory. Trial and error may be necessary.

Multiple Printing

Because of the limitations of using the camera for combining images, it is often more convenient to make multiple exposures at the printing stage, using a number of different negatives. This has the advantage that the negatives are not affected and can be used for several attempts until a satisfactory print is obtained. They can also continue to be used for making straight prints.

Multiple printing is most useful in cases where a dark subject is to be superimposed on a light area in the print. It cannot easily be used in the reverse situation.

To make a multiple print using two separate images, place each negative in turn in the enlarger carrier and adjust the height of the column to give the correct degree of enlargement. Trace the outlines of the two images on a piece of white drawing paper in the correct positions for the final print. This sketch acts as a template when positioning the printing paper on the enlarger baseboard. A masking frame is extremely useful for ensuring that the printing paper is always placed in exactly the same position as the template.

The straight print The occasion was the re-enactment of a historical battle. A man dressed as King Charles I asked if I had taken any photographs of him, as he would like copies. I hadn't, and furthermore I had run out of film. All I had left was an old roll of lith film (see Chapter Four – Lith Film). Knowing full well that the chances of printable results were remote, but knowing equally well that it was the only possibility of producing a picture, I loaded the lith film and took some shots. The results were dreadful, lacking detail both in the highlights and the shadows. Bright sunshine is much too harsh and quite the wrong condition for using extreme contrast film.

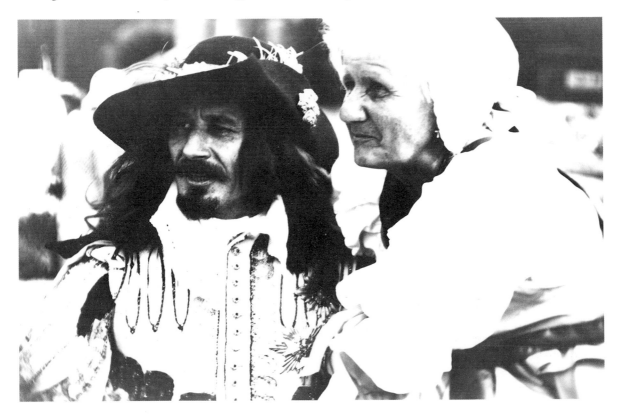

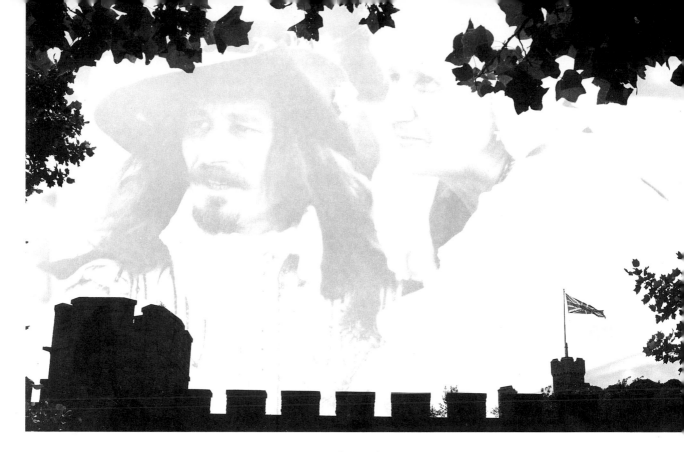

Carolus Rex I made a composite print by super-imposing two negatives on the same sheet of paper. 'His Majesty' liked this one and I have a letter from him which says: 'Alas, 'tis a pity time did not permit cameras in the seventeenth century . . . you would have been "By Appointment, Photographer to His Sacred Majesty Charles R"!'

Use the template to line up the first negative and focus it, then, with the enlarger's red safety filter in place, remove the template and accurately replace it with a sheet of photographic paper. Move the red filter out of the way and make the first exposure. Without developing it, mark the back of the photographic paper with a light pencil mark and place it in a lightproof box. Marking the paper helps you to reposition it the same way up for the second exposure. Place the second negative in the enlarger, focus the image and align it according to the template. With the red filter in place, return the printing paper to the enlarger baseboard in place of the template. Use the mark on the back to ensure it is the correct way up. Make the second exposure and develop the print.

Some trial and error is needed to determine individual exposure times. A certain amount of the first exposure is necessary to overcome the inertia of the paper without visible effect. Once the paper is 'activated', however, all further exposures contribute directly to producing tone. The second exposure will therefore probably need to be shorter than you expect.

SANDWICHES

The term sandwich is used to describe a combination of any number of translucent images bound up together in close contact and in register, through which light is transmitted in order to produce a composite picture.

Two negatives, or two transparencies, placed emulsion-to-emulsion and held together between glass plates, are the simplest form of

sandwich. Three or more negatives or transparencies are equally possible. Sandwiches may also include high contrast images using lith film and these can be particularly effective. (These are specifically dealt with in Chapter Four – Lith Film.)

Whether you use negatives, transparencies or anything else, the technique is identical. Two sheets of glass are needed to hold the components of the sandwich in intimate contact. For negatives, a glass enlarger carrier is suitable; for transparencies, glass slide mounts can be used. The negatives or transparencies should be placed emulsion-to-emulsion to ensure the closest possible contact between the images. This is important because both images need to be focused together – on the enlarger baseboard or the projector screen. The two negatives or transparencies can be held together in register by tiny strips of adhesive tape positioned on the rebate of the film.

Bonfire Night If you want some good photographs of your cat, put it out in the garden on bonfire night! Just in case anyone takes me seriously and accuses me of cruelty to animals, let me explain that, whilst the fireworks were indeed photographed on Guy Fawkes Night, the cat was happily sitting in the garden one sunny day in March. The print was made by sandwiching three separate negatives. The component parts are shown on page 35.

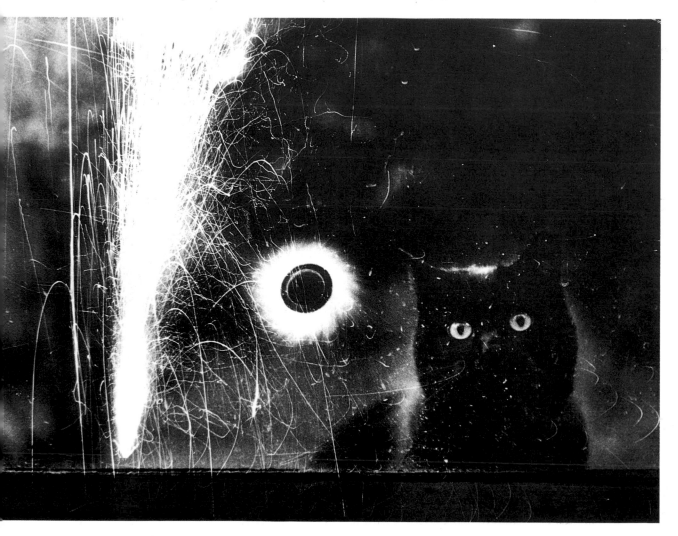

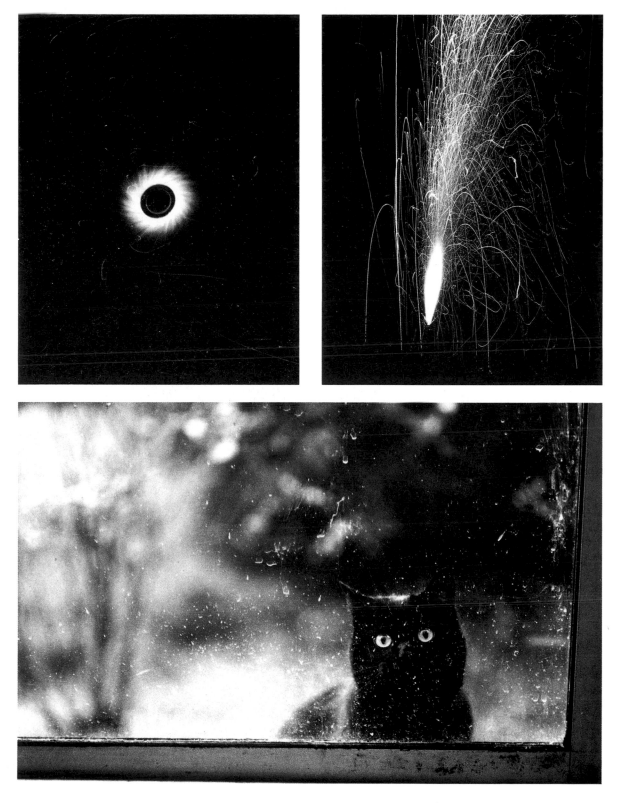

If printing a sandwich, the use of a small aperture on the enlarger lens helps to forgive a slight difference in focus between the images. If three or more images are combined, it is impossible for the emulsions of each to be in mutual contact. In this case, the minimum possible aperture should be used for printing, even if this means a long exposure time.

Sandwiching Negatives

In the same way that multiple printing allows you to add dark-toned subjects to light-toned backgrounds, sandwiching negatives lets you do the converse. This is logical as only the clear areas on a negative allow a secondary image to show through. When printed as a positive print, the secondary image appears as a light tone against a darker background. The ideal negatives for sandwiching are those with relatively clear areas which coincide with the main subject areas of their partners.

Sandwiching Transparencies

Two or more transparencies can be sandwiched together as easily as negatives, using exactly the same method. The advantage of using transparencies is that colour can be introduced into the composite image.

Slide sandwiches can be projected or printed. If frequent projection is likely, it is worth copying the sandwich on colour transparency film to give a permanent single image. Various methods of copying are described on page 39. If you prefer a print, use a positive–positive colour printing process.

Hallucination A sandwich of two colour transparencies, bound together emulsion-to-emulsion. The face was originally a black and white print, and was rephotographed on colour transparency film. The red background is a photograph of the attractive casing of a piano accordion.

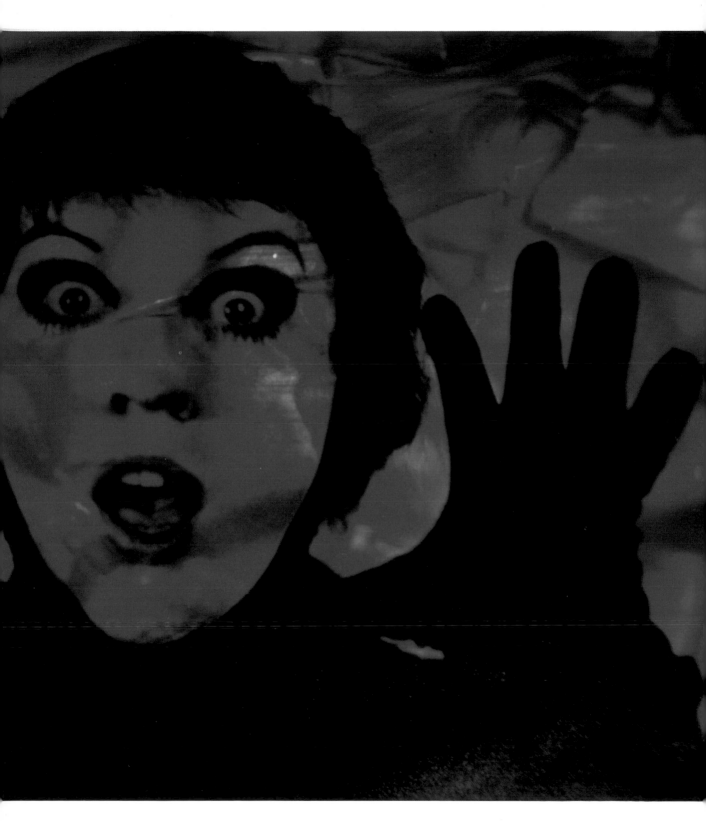

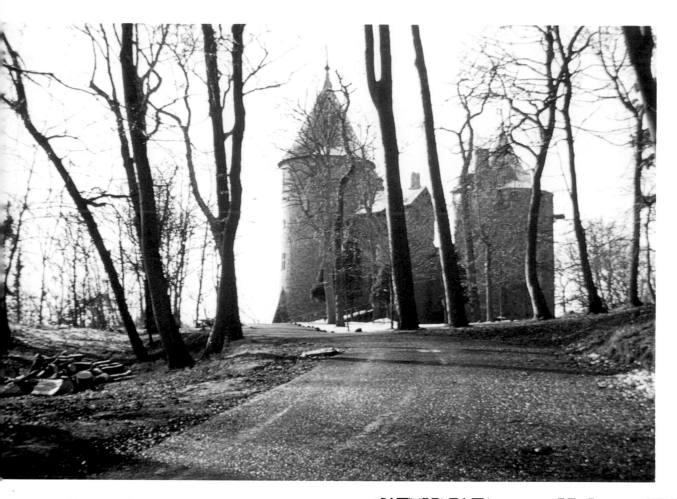

The original colour transparency This rather dull, life-less, colour transparency was the source of a very different picture produced by sandwiching and copy-ing. On the original, the lighting is flat and the colours pale, yet the shapes which make up the picture are somehow pleasing. The trees, the fairy-tale castle of Castell Coch in South Wales and the curving road are all elements which offer potential for a much more interesting picture, once the inadequacies in the lighting and colours have been overcome.

Isolating the basic shapes Here, the basic shapes of the colour transparency have been isolated by copying on high contrast black and white film (see Chapter Four – Lith Film). This treatment produces a drastically simpli-fied image in bold black. The image is much too stark in its present form, but it creates a useful template for the reintroduction of selected colours by sandwiching with a suitable colour transparency.

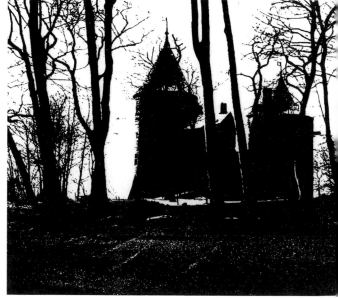

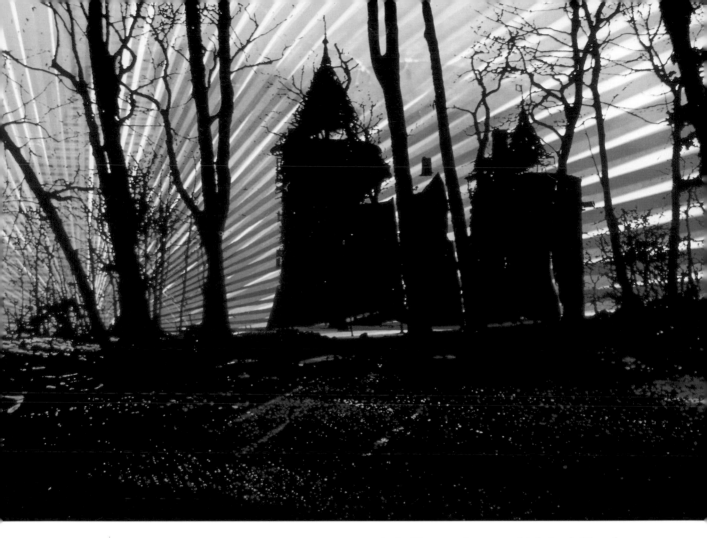

Enchanted The finished picture, created by sandwiching a colour transparency with a black and white high contrast positive. The dramatic effect of the 'sunrise' – in fact, a small portion of an old poster – is sufficient to complement the powerful silhouette of the castle.

Copying Transparencies

Transparencies, whether singly or as composites, can be copied using an ordinary single-lens reflex camera, provided it has facilities for close-up photography. Alternatively, you may be fortunate enough to have access to a slide copying device, such as a Bowens Illumitran. Assuming a camera will be used, it is necessary to be able to photograph at a reproduction ratio of 1:1, which means that a macro lens, extension bellows or extension tubes will be needed. Close-up lenses, which look like clear filters and screw on to the front of your camera lens, are also suitable, and are considerably cheaper, but these supplementary lenses give inferior image quality. Whatever equipment is used, though, the principle is the same.

First, fit the camera with the close-up accessory to be used, then position the transparency in front of the camera lens. It is absolutely crucial that the transparency be perpendicular to, and on the axis of, the lens. At the high degree of magnification necessary for copying transparencies, the depth of field is minuscule and any slight inaccuracies in positioning will be apparent as unsharpness in the copy transparency. Slide copying attachments are available for most single-lens reflex cameras and

these ensure the transparency is accurately and critically situated. They usually have a sliding mechanism to allow the distance between the transparency and the lens to be varied to give the correct degree of magnification. After focusing the camera the copying set-up is ready for use. Before proceeding any further, however, attention should be given to the lighting used to illuminate the transparency.

Lighting for copying must be both even and of the correct colour temperature. Daylight is convenient and has the advantage that the final appearance of the image can be assessed through the lens before making the exposure. On the other hand, the colour temperature of daylight varies. In the mornings and evenings daylight has a distinct yellow hue. By comparison, photographing in shadow at midday on a beautiful summer's day gives pictures a strong blue hue. The day for copying should therefore be chosen carefully. A bright but overcast day may offer the best compromise.

To determine the correct exposure for daylight copying, through-the-lens metering can be used as for your normal photography. Nevertheless, it is prudent to take several exposures, bracketing by one or two stops – in one third of a stop increments – on either side of the exposure indicated by the meter.

In order to ensure colour consistency when copying, use electronic flash. The light output by modern flashguns gives neutral-coloured results on daylight-balanced film. Also, through-the-lens flash metering takes most of the guesswork out of exposure calculations, so you can virtually guarantee spot-on exposures every time.

Texture Screens

Texture screens are special negatives carrying images of patterns or textures. They are specifically intended for sandwiching with conventional negatives, so that the pattern or texture of the screen appears on the final print. Texture screens are used in exactly the same way as

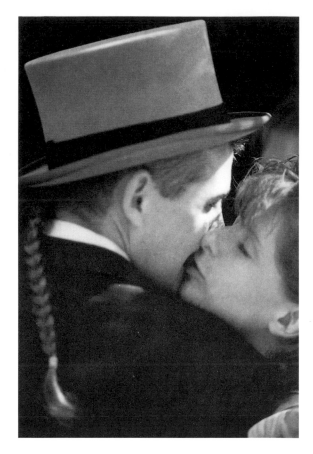

The straight print made without the texture screen.

described above for sandwiching negatives.

The effect of using a texture screen is to break up the printed image, which helps relieve the monotony of large areas of tone. Used well, they can give considerable impact to a print, but they should be used sparingly. They will not rescue inadequate negatives. Use them only if you feel they add something which is essential to the success of the picture.

The Kiss This spontaneous shot of two guests at a wedding has caused some confusion, because the pigtail is his not hers. The negative was not quite sharp, so the final print was made via a Paterson reticulated grain texture screen, which not only hides the unsharpness, but adds an ethereal, dreamy quality to the picture.

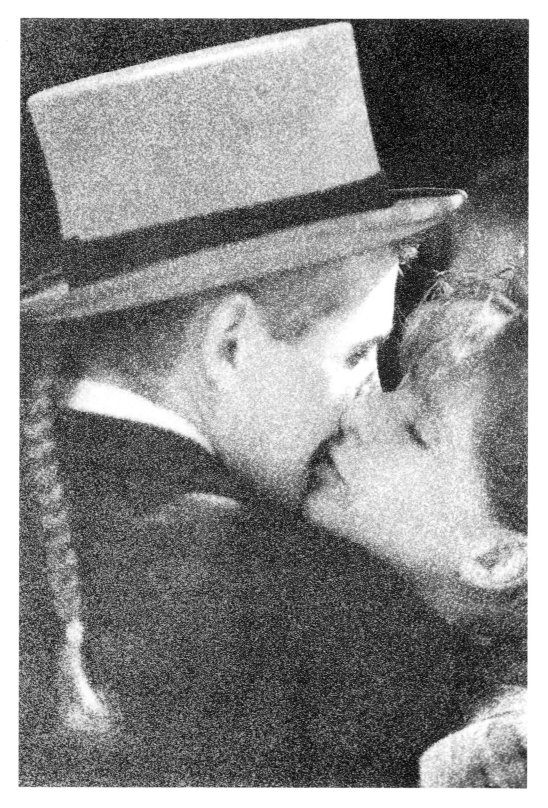

Texture screens can either be bought or you can make them yourself. Paterson make a set of 12 different screens which includes such patterns as dot screen, reticulated grain, rough linen and steel etch.

Alternatively, it is fairly easy to make a screen using any texture you like. All you have to do is find a suitable textured or patterned surface and photograph it. Concrete, gravel, wood and textiles are all possibilities, but any other material can be used if it creates the desired effect. Choose an example of the selected material which is free from blemishes, and make sure the lighting is perfectly even. Photograph it as near to perpendicularly as possible, and use only half or less of the

Welcoming Party The texture screen used for this Royal Ascot picture was a 'dot screen', which resembles the coarse print of a newspaper photograph. For a journalistic style photograph, particularly one taken in dull light, this screen can add impact and effectively 'brighten up' the image.

Flower A successful picture which has been accepted in many international exhibitions, but which originated as an unsharp colour slide. The final picture was made by sandwiching the slide with a piece of lens-cleaning tissue. Lens-cleaning tissues are strong, but have fairly low fibre density, making them relatively transparent and ideal to use in picture-making.

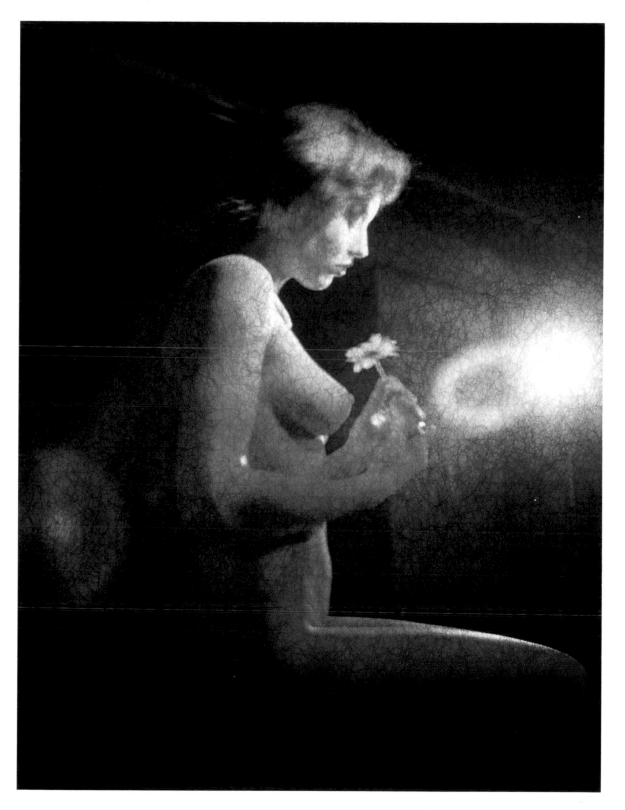

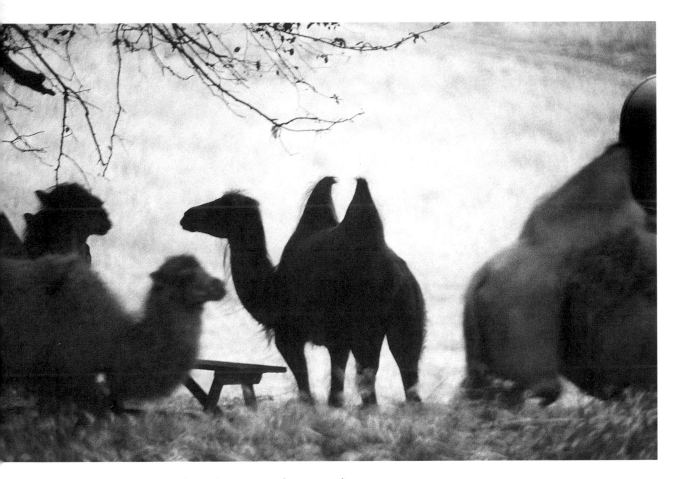

exposure indicated by the meter. If you set the exposure suggested by the meter, the sandwich may be too dense to allow you to make a satisfactory print.

You can even use non-photographic texture screens, made from any form of translucent material which has a suitable texture. Tissue papers of various sorts offer much potential here, provided they are thin enough to allow the image to show through when in combination. Tissue paper also has the advantage that it can be equally effective when sandwiched with a colour slide.

Not only can texture screens be sandwiched with negatives but, if large enough, they can be placed over the paper during printing. To keep the screen in close contact with the paper, a sheet of glass is laid over the top and this

The straight print

ensures the texture prints sharply. Materials such as greaseproof paper can produce some very pleasing results when used in this way.

If the screen is not kept in close contact with the paper, the image will appear unsharp and shadow areas will tend to bleed into highlight areas. This opens up a whole new area of soft focus creativity. Instead of placing the sheet of glass on top of the paper, try suspending it in the enlarger beam, somewhere between the lens and the paper. Different translucent materials can now be placed on the glass, and the effect on the image falling on the baseboard judged. You could use silk stockings or petroleum jelly smeared on the glass but dense material may obliterate the image.

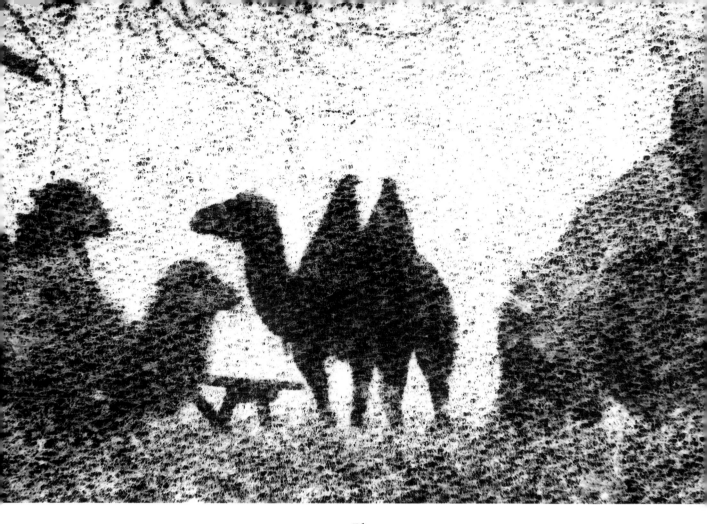

Camels An alternative *ad hoc* texture screen is toilet paper! What could be simpler than to make a picture from such a readily available photographic medium? 'Soft' toilet paper was sandwiched with the negative in the example shown here. Toilet paper has a denser, less distinct fibre structure than lens-cleaning tissue and may not be suitable for all sandwiches, so you should select the most appropriate material for your purposes carefully.

MONTAGE

So far in this chapter we have considered methods of combining images which involve photographic procedures. Now we start to look at ways of bringing together images from different negatives using craftsmanship, rather than photographic skills.

Photomontage

A photomontage is a picture constructed from several separate prints. The prints are cut out and pasted together to form a new image. The montage is then rephotographed. Any number of component prints can be used and any fantasy is possible. This is a technique to be used if an unlikely end result is required. It is time-consuming, so think carefully before you start, and plan each stage in advance. Most importantly of all, make a rough sketch of the general layout of your envisaged picture, so you can work to a template.

Assuming you have already taken the component photographs which you wish to montage together, first make a print of each. It may even be an idea to make two or three copies of each in case of mistakes when cutting them out.

Be careful to print to the correct size for the final picture. Try to choose negatives with similar lighting and contrast ranges, so they will look convincing when fitted together. If possible, make all the prints at once to ensure the same depth of printing.

Using a sharp scalpel or fine craft knife, cut out the area of each print which you intend to use in the montage. Be very accurate and take care if the edge of the chosen area is ill-defined or intricate.

The photomontage can be assembled in one of two ways. The component parts can either be mounted edge-to-edge, so that they butt up to each other, or they can overlap. There are advantages and disadvantages to each method. The edge-to-edge technique is useful for relatively simple shapes, but it is difficult to achieve an accurate fit if the shapes are intricate. The overlap method is much easier, but rephotographing the artwork can be problematic because of shadows cast by the overlapping edges. On the other hand, overlapping ensures there are no gaps between adjacent prints.

If the individual prints are to be overlapped, it is worth trying to minimize the thickness of the paper, at least at the edges. Single-weight paper rather than double-weight helps up to a point, but shadows are still likely. The paper at the edges of the cut shapes can be thinned by carefully rubbing the back with very fine sandpaper, but this can be difficult, if not disastrous, when the shape is complex.

Three apparently unrelated pictures These formed the component parts of this photomontage. The end result is an unlikely situation that could not have been achieved by straight photography. (The cat is incidental; the negative happened to have an area of texture which was suitable for use as the 'wall'.)

The Sleeping Partner The finished montage. This picture was rejected from a local camera club's monthly competition, yet went on to win a certificate of merit at an international photographic exhibition in China.

Winners and Losers (*opposite*) This photomontage took many days of work to prepare and assemble. Thirteen different prints were made initially, each carefully printed to ensure the size of face was correct for its position in the crowd. The photographs selected were near misses; photographs of people whose expressions were worthy of further consideration, from a photographic point of view, but where the background or the lighting were too poor to merit printing individually. Each print was cut out and adjacent components were dovetailed, as in a jigsaw, so that there are no overlaps at all in the final montage. The result is an unlikely crowd of facial expressions which no one could ever hope to see together in a single shot at the races.

The two original photographs (*left*)

Chinaman in a Mask (*below*) The original background in Canton for this masked Chinaman was most un-inspiring, so I decided to 'move' him to a more inter-esting setting within the same city. The two individual prints used for the montage were made on resin-coated paper. The print of the Chinaman was stripped from its backing, and the flimsy emulsion layer mounted on the surface of the background print. The montage was then rephotographed.

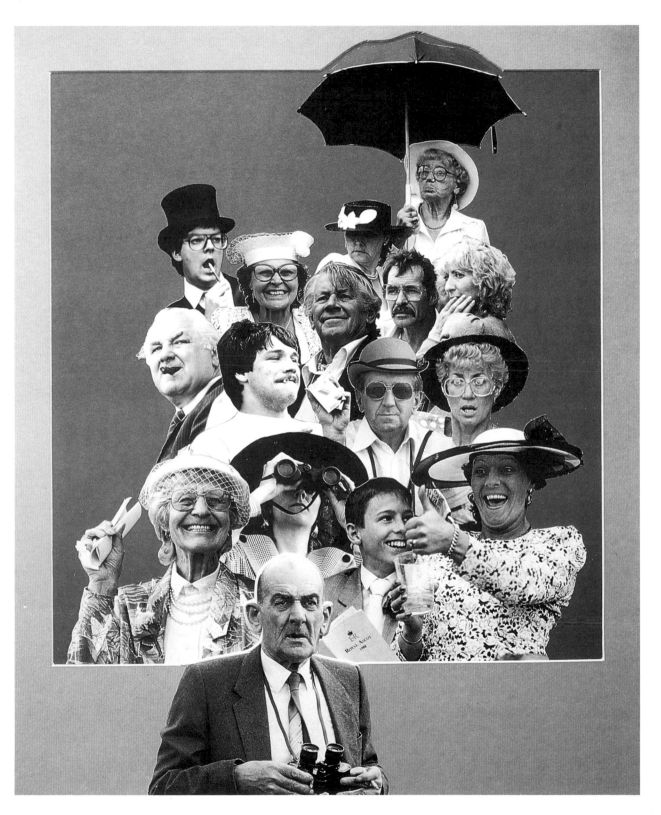

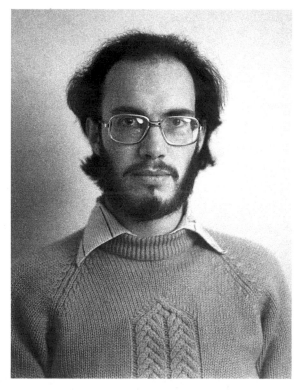

The concept of my self portrait was sketched on a scrap of paper (*top left*). **The straight print** used as the basis for the montage is shown *top right*. **A high contrast positive and negative** were made from the original negative (*bottom left* and *right*), using lith film. Full size prints measuring 15 × 12 in (27·5 × 30 cm) were then made from the lith positive and negative and each was cut into identical rectangular pieces. The final print was made by mounting together alternating positive and negative pieces.

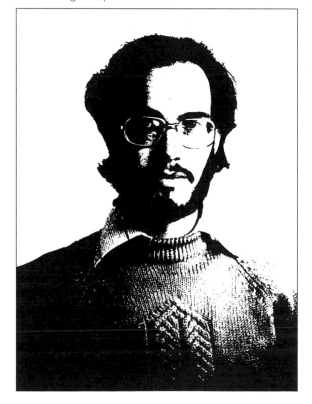

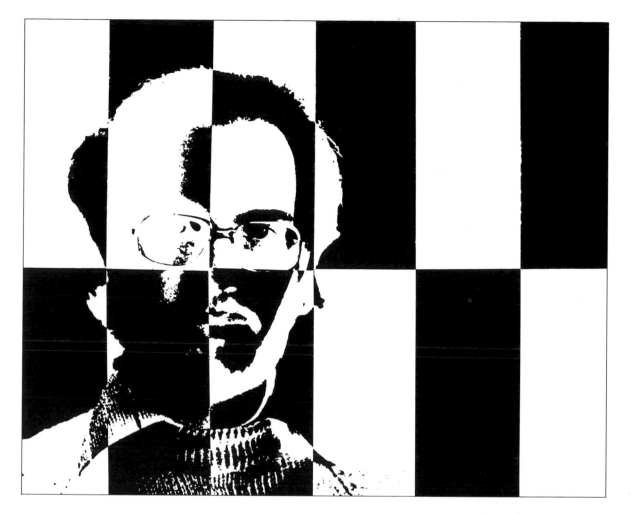

Self Portrait

A good method is to make the prints on resin-coated paper. Resin-coated paper has a very interesting property which is extremely useful for photomontage work: the emulsion can be stripped from its backing paper. This is easier than it sounds. Use a scalpel at one corner of the print and gently split the thickness of the paper so that a corner of the emulsion lifts away from the backing. Once there is enough emulsion to grip between the fingers, the whole surface of the print can quite easily be peeled from the backing by hand. The emulsion is fairly strong and usually comes away cleanly. It is better to strip the print before cutting out the shape of the image, to avoid having to tug at an intricately shaped piece of emulsion.

Whichever method is used for reducing the thickness of the paper, the components of the montage are now ready for assembly. Any suitable adhesive can be used, but aerosol spray adhesive is probably the most convenient. Spray the reverse of the prints, taking care to avoid spraying adhesive on the surface, and assemble them in the correct positions. Use a rubber roller to ensure they are well stuck down and allow the adhesive to dry. It is useful to place the artwork in a press or under a heavy weight to keep it flat.

The artwork can now be photographed to

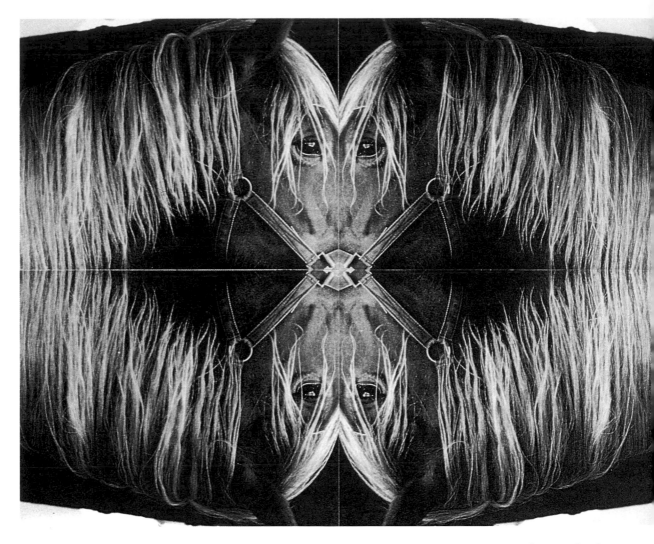

Demons Simply repeating the shape of a familiar subject can sometimes give an image a whole new meaning. A friendly horse, for example, can be transformed into a pattern of horned demonic faces, and old men with walrus moustaches.

produce a single negative, so that multiple prints of the montage can be made. Use diffuse, multidirectional lighting for this copying stage to minimize shadows.

Kaleidoscope Pictures
Kaleidoscope pictures are photomontages of a sort. Several prints of the same photograph are assembled together in a regular pattern to give a repeating image which resembles, to some extent, the view through a kaleidoscope. Half the prints are made with the negative in reverse to give a mirror image, and these are mounted adjacent to, and alternating with, prints made

the correct way round. Any pattern can be followed, provided it is regular, and squares, rectangles, triangles or polygons are suitable components.

The resulting photographs are interesting in that the original image ceases to be the most important element of the picture as such. Instead, the final effect is determined by the shapes and tones of the original image and the way they reflect each other when placed against imaginary mirrors. It is often difficult to envisage the eventual result until it has been produced. The most suitable images are often those which have strong diagonals, where parts

of the subject are in contact with each of the four sides of the frame.

In Situ Montages

So far we have considered only photographic components in montages, but there is no reason at all why you should not combine photography with other elements if you see fit. With a little imagination you can introduce anything you like into a picture, and a montage consisting partly of photography and partly of 'real life' can very often be effective.

This concept can be applied in two quite distinct ways. First, you can use any two-

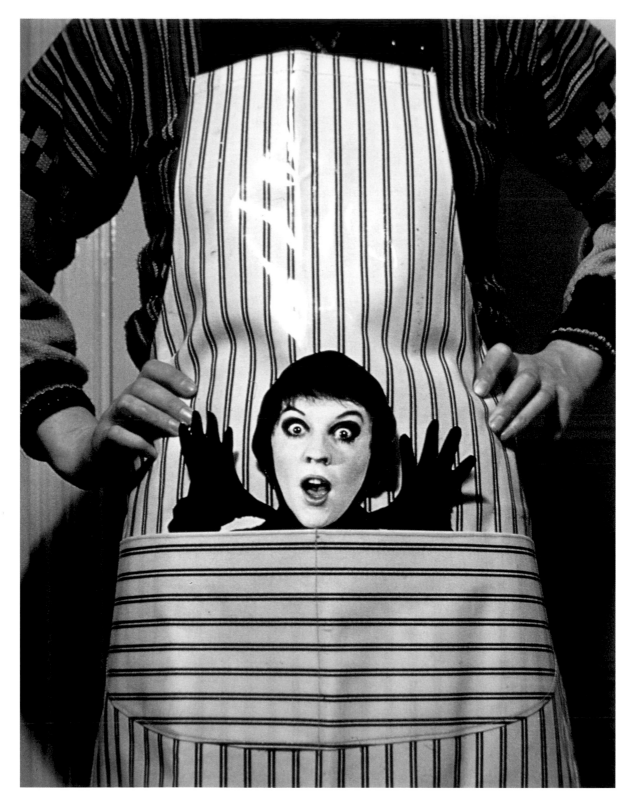

The Apron Pocket This is effectively an *in situ* montage, since a printed image has been combined with a real human subject and then been rephotographed. The picture was originally made as a way of finding a use for an otherwise scrap print. The 20 × 16 in (50·8 × 40·6 cm) print was rescued from the waste bin and the subject cut out with a pair of scissors. It was then placed in my wife's apron pocket and photographed on colour transparency film.

dimensional material in a montage, whether it is of photographic origin or not, pasting it into your artwork in exactly the same way as for a photographic print. There is no limit to the materials available to you. This is effectively what artists call collage, and it opens up a whole new world of creative possibilities.

There can be no rules to collage, because of its vast scope. Use your imagination and let it run wild. Do what you like, and use whatever you want in your pictures. Don't let it worry you if other photographers tell you it's not photography or it's cheating. They may be right, but does it really matter?

Collage can be used as a feature in the presentation of prints, as well as in image making as such. This is discussed in more detail in Chapter Six under Sympathetic Surroundings (page 107).

The second approach is to introduce a photographic image into a real life situation – photographing the set-up and presenting it as a straight picture.

INTRODUCING COLOURS

A black and white print can be any colour you choose.

Perhaps the most obvious way of converting black and white into colour is to print a black and white negative on colour photographic paper. Both positive and reversal paper types can be used, although the effects obtained are quite different. With reversal paper, such as Ilfochrome Classic (formerly called Ciba-chrome), the negative prints as negative, not positive. With both paper types the choice of colour in the print can be controlled by the filtration selected, remembering, of course, that the positive C-type papers require filtration complementary to the colour desired.

Whilst this technique alone could fill a book, it only scratches the surface of the subject of this chapter, since there are many different ways of colouring black and white images. The emphasis will, therefore, be on colouring prints rather than on colour printing.

Fundamentally there are two quite different ways of introducing colour into a black and white print by hand. One has the effect of colouring the black part of the picture, but does not affect the white. This is known as toning, and is a chemical process whereby the silver in the image is converted to something else. The other way is to colour the white part of the picture, leaving the black unaffected. This is known as tinting, dyeing or hand-colouring.

It is also possible to buy monochrome printing paper in various colours. The Kentmere Kentint range of pre-coloured resin-coated papers includes red, orange, yellow, green and blue, not to mention gold and silver. However, with the exception of the metallic colours, the same effect can be achieved by dyeing conventional monochrome prints. Dyeing has the advantage that a wider range of colours can be achieved and it also cuts down on the number of boxes of paper it is necessary to keep in stock.

There is a third, if more complex, colouring process, known as etch bleach, which affects both the black and the white parts of the print in different ways.

The comparison between toning, tinting and etch bleaching can best be shown by the following table:

Colouring Process	Effect on the original tones	
	Black	White
Toning	Coloured	White
Tinting	Black	Coloured
Etch Bleach	White	Coloured

All three methods of introducing colour into a photograph involve working on a conventional silver-based print. Unlike toning and tinting, however, the etch bleach process requires the print to be in negative.

TONING

The black part of a monochrome image is metallic silver. It can be converted by a variety of chemical reactions to a range of different coloured derivatives, using toners. Toners come in many different forms, but they act in one of three basic ways:

- By replacing the silver with another metal.
- By converting the silver to a coloured silver salt.
- By converting the silver to a compound which is capable of adsorbing a colour dye. Such compounds are known as mordants.

Different toners produce different image colours, and the choice of toner depends on the picture subject and on the effect desired. Toners are available for colours ranging from rich to warm blacks, through a range of browns, to reds, greens and blues.

If you wish to use a wide range of different toners, you should expect to have to make up at least some of them yourself, because they are not all commercially available. You will find many formulae for toners of different colours in textbooks such as *The Focal Encyclopedia of Photography* and *The Ilford Manual of Photography*. Toners often include small amounts of ingredients which can only be bought in large quantities, so it may be more convenient to buy as ready-made solutions the toners which do exist commercially.

A word of warning is perhaps necessary if you are thinking of using toners, because many of them, for example selenium and lead, are quite toxic. Nevertheless, if you wear gloves and are careful how you handle them there should be no problem.

The table below shows a small sample of the wide range of colours possible with metal and metal salt toners – the metal or salt responsible is indicated. Even more colours are possible with dye toners because of the unlimited range of dyes which mordants adsorb.

TONERS AND THEIR EFFECTS

Toner	Colour	Silver converted to:
Sulphide	Sepia	Silver sulphide
Selenium	Purplish-brown	Silver selenide
Uranium	Reddish-brown	Silver uranium ferrocyanide
Copper	Warm brown to light red	Metallic copper
Lead	Yellow	Lead chromate
Vanadium	Green	Vanadium ferrocyanide
Iron	Brilliant blue	Ferric ferrocyanide (Prussian blue)
Gold	Blue-black	Metallic gold

Apart from the obvious use of toners to change the colour of a print, some of them have the advantage of being more permanent than the original silver image. Toners such as sulphide, selenium and gold are, indeed, often used specifically for archival purposes. Toners based on colour dyes may, however, be less permanent than the original image.

The method of using toners varies according to the toner used. Some are single solutions; others consist of two or more solutions which, in some cases, have to be mixed before use and in others are used separately. Consult the instructions for your particular toner before proceeding. Whichever toner you intend using, the print you wish to tone should be fully developed with clear whites and rich shadows. The actual colour you achieve in toning depends not only on the toner you choose to use, and on the extent of toning, but also on the paper used to make the original print. Some brands tone better than others and a degree of trial and error is likely to be needed before you obtain the best result.

When you have run out of different toners to use, try experimenting with mixed toning, which involves sequential toning of the same print, using different toners. For example, if a sepia toned print is then gold or iron toned, a bright red image can be produced.

Sepia Toning

By far the most commonly used toner, not to mention the smelliest, is sulphide, which produces a deep rich brown colour – referred to as sepia. It is very popular because it imparts a 'period' or 'olde worlde' appearance to a print. Sepia toner is available from most photographic retailers as ready-made solutions, but the formula is so simple that it is easy enough to make it up yourself. Sepia toner consists of two separate solutions, a bleach and the toner itself, which have the formulae given below:

Solution A – Bleach		Solution B – Toner	
Potassium		Sodium sulphide	15 g
ferricyanide	15 g		
Potassium bromide	15 g	Water	to 1 litre
Water	to 1 litre		

Sepia toning is a two-step process and is carried out on a conventional monochrome print in normal room lighting. The print is first bleached by immersing it in Solution A for a few minutes. The image almost disappears to leave nothing but a very pale straw-coloured image. The print should be rinsed briefly and then it is immersed in Solution B – the toning bath. Very rapidly the image reappears, only this time it has a rich sepia colour.

Selective Toning

Prints can be selectively toned, if required. In other words, a portion of the print can be toned without affecting the rest of the picture. In the case of sepia and other means of toning which have an initial bleaching step, the selectivity is based on the fact that only bleached areas of the print respond to the toner. Unbleached areas are unaffected. Selective toning is therefore achieved by selective application of the bleach, rather than the toner.

The area of the print to be toned must somehow be defined before proceeding further. Is a definite edge required with an abrupt change from black to sepia (or other colour)?

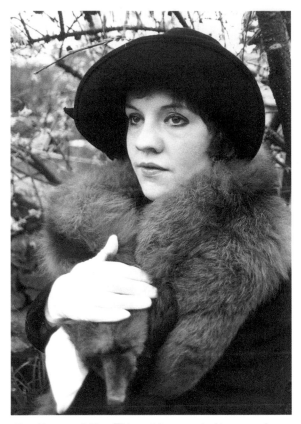

Fox Fur – and Rita This outdoor portrait was sepia toned to enhance the period feel of the costume.

Or do you prefer a diffuse area, giving a gradual change? The answer to this question determines the procedure to be adopted next.

If a diffuse area is to be toned, apply the bleach to a dry print using a brush, sponge or cotton wool, whichever is the most appropriate or easiest to use. Apply the bleach carefully, concentrating on the centre of the area to be toned, but allowing only a little of the bleach to reach the edges of the area. Continue until the centre of the area is fully bleached, the edges partially bleached and the remainder of the print unbleached. Quickly rinse the print and immediately immerse it in the toning bath. The bleached areas will take on the colour in proportion to the degree of bleaching.

If a sharp edge is called for, the print must be masked to protect the surrounding area. There

are a number of different ways of doing this. Nail varnish makes a very convenient masking fluid; it dries quickly and it comes in a bottle already fitted with a tiny brush, but it is only suitable for masking small areas. Paint the nail varnish on the surface of the print, carefully following the outline of the area to be toned, making sure that none spills over into this area. A band an inch or so wide may be all that is needed to restrict the bleach to the relevant parts. Allow the nail varnish to dry. Apply the bleach as before, using a brush, sponge or cotton wool. Take care not to splash the

Pollution A straight black and white print from this negative, taken at Port Talbot in South Wales, looks far too pictorial and attractive. It says nothing about pollution. The print was, therefore, selectively toned by applying bleach on a wad of cotton wool to the sky. The smoke from the chimney was masked using nail varnish to define the area to be toned and bleach was applied to this area using a fine brush. The print was then immersed in the toning bath until the correct depth of sepia colour had developed in the bleached areas.

unprotected print outside the masked area. When bleaching is complete, immerse the whole print in the toning bath. Wash and dry the toned print as usual. It is then a simple matter to remove the nail varnish using acetone or chloroform.

As an alternative to nail varnish, Cow gum can be used as the masking agent. Cow gum is more difficult to apply accurately and evenly, but it can be used to mask larger areas. To remove it from the print, it can simply be rubbed off with the fingers.

The best method of masking, but one which needs some skill, is to use Frisk masking film. Frisk is a very low tack self-adhesive film which is supplied on a backing sheet. It is made for airbrush work (see section on page 63) and is available in rolls of various widths. For use on 20 × 16 in (50·8 × 40·6 cm) exhibition prints a roll of at least 16 in (40 cm) will be needed. Most artists' suppliers stock it, particularly if they specialize in airbrush requisites.

To use masking film, peel it from its backing

sheet and apply it to the entire surface of the print. Burnish it down well. Using a very sharp scalpel and a very light touch, score the film gently, following the outlines of the areas to be treated. Be careful not to use too much pressure – it is all too easy to leave a depression on the print surface. Peel the film from the area to be toned, leaving an aperture in the masking film. The print is now protected from the effect of the toner, with the exception of the exposed area.

Immerse the entire masked print in the toning solution as usual. When the desired colour has appeared, hang up the print to drip dry. Only when the print is dry should the masking film be removed.

Blue Toning – A Panel of Denim Pictures

The following photographs form part of a panel of framed exhibition pictures on the theme of 'Denim', and were made by selective toning. The blue toner used was an iron toner, a one-bath process which converts the silver image to ferric ferrocyanide, or Prussian blue. The depth of colour can be controlled by adjusting the time the print is left immersed in the bath. The longer the treatment, the brighter and stronger the colour.

Many different formulae have been published for iron toners, one of which is given below:

Solution A		Solution B	
Potassium ferricyanide	1.7 g	Ferric ammonium citrate	15 g
Sulphuric acid	3 ml	Sulphuric acid	3 ml
Water	to 1 litre	Water	to 1 litre
To use, mix equal parts of solutions A and B.			

Alternatively, iron toner is commercially available as two ready-made concentrates, to be mixed immediately prior to use.

In the 'Denim' panel, the untoned portion of each print was protected by masking film, as described above.

To give an added touch to the exhibition panel, each print was framed with a surround of real denim material. To make the denim surround, each piece of material was dry mounted on a 20 × 16 in (50·8 × 40·6 cm) sheet of thick card, using a heavy duty mounting press. An aperture was then cut in each one, the same size as the picture, using a bevel cutter. Creative mounting techniques are described in full in Chapter Six – Creative Mounting.

TINTING

Compared with toning, tinting is a very simple affair. It is a physical, rather than a chemical, process and essentially anything which colours white paper can be used. The range of potential materials is vast and includes inks, paints, dyes, coloured pencils, felt-tip pens, lipstick and boot polish. The choice of colouring material depends to some extent on the area of print to be coloured. For small areas, pens or pencils, or ink, paint or food colouring applied by brush may be appropriate. For larger areas, an air-brush or fabric dye may be more useful.

Fabric Dyes

The Dylon range of powdered fabric dyes is a very versatile and readily obtainable source of many different colours. The dyes are intended for dyeing clothes and are sold in high street multiples, department stores and hardware shops, to name but a few. Two different types have been formulated – for use either in hot or cold water. Before you start to worry at the prospect of boiling your best exhibition prints, I should explain that, for photographic use, both types can be used cold and are equally applicable.

If, in spite of the wide range of colours which Dylon produce, you cannot find the right one, you can mix the dyes to obtain the exact colour you require.

Don't expect to get clear instructions with Dylon dyes. The manufacturers never expected

Dungarees The surround on this picture came from the leg of an old pair of jeans.

F.U.s Relatively little masking was involved in this picture, because it is predominantly of denim.

them to be used by photographers. Fill a developing dish with sufficient water to immerse your print and then add the powder, little by little, until the solution gives the correct depth of colour on a test picture. Be sure to mix the dyes well. It doesn't take much undissolved powder in the bath to ruin a picture. Dyeing is a relatively slow process and the print may have to be left in the dye bath for anything between five minutes and an hour. It is, therefore, important to keep the print agitated to ensure an even coverage of colour.

Dylon dyes of different colours have quite different physical properties. Some are readily soluble, whilst others take time to dissolve. Some require the addition of salt or washing soda, but the instructions do tell you this.

When the print has been satisfactorily coloured, remove it from the bath and hang it up to drip dry without rinsing it. With many of the dyes, rinsing will remove the colour.

Prints may be selectively dyed, using the masking techniques described on page 58 under Selective Toning. Many examples of pictures made in this way are shown on pages 64 and 65 and in Chapter Six – Creative Mounting.

Airbrush

There is nothing more versatile for hand-colouring than an airbrush, which is essentially a mini aerosol spray can. It can be used to deliver all sorts of inks, dyes and water-soluble paints. It is not easy to use, however, and plenty of practice is needed to perfect the technique. As with the methods described above, the print is first masked so that all but the area to be coloured is protected.

Racing Colours Both the man's shirt front and the umbrella have triangular features and are black, white and red. A hand-coloured print emphasizes these similarities, but a conventional colour print would have had other, distracting colours in the scene, such as the bright yellow chair. The monochrome print was coloured using Dylon dye, 'Mexican red', having first masked all but the areas to be dyed, using Frisk.

ETCH BLEACH

So far, this chapter has covered two diametrically opposite ways of colouring a black and white print – toning and tinting. As toning colours the black part of the print without affecting the white, and tinting colours the white part with no effect on the black, one could be excused for believing there is no other possible combination. This is where a third colouring process – etch bleach – enters the scene.

The etch bleach process affects both the black and the white parts of a print in a very dramatic way. The black is bleached away to leave white, and the existing white part can then be coloured.

Etch bleaching can only be carried out on resin-coated paper, because the process depends upon the fact that the emulsion is water absorbent whilst the plastic backing of the paper is not. The bleach has the effect of not only removing the tone from the dark areas of the print, but of physically stripping the emulsion away from the plastic backing. The emulsion is unaffected in the areas which were originally light in tone. The bleached print, which has the appearance of a completely blank sheet of paper, now contains a latent image formed by distinct 'islands' of emulsion on a plastic sheet. This latent image can now be 'developed' by immersion in a water-based dye. Being water absorbent, the emulsion readily accepts the dye, but the dye simply runs off the plastic backing. The image which now appears is a negative of the original image because it is the white parts of the print which take up the dye. For the etch bleach process, therefore, it is necessary to start off with a negative image.

So much for the general principle of the etch bleach process, but how is it achieved?

First, a black and white print has to made of the actual size required, and it has to be negative. High contrast images work best,

since they give a sharp edge between areas of dark and light tone. There are a number of ways in which a suitable negative print can be made. A black and white negative can be copied on lith film (see Chapter Four – Lith Film) to give a high contrast positive which is then printed on resin-coated paper. This is probably the best method. Alternatively, a conventional black and white print may be contact printed on a sheet of resin-coated paper, using the print as a paper negative (see Chapter Five – Exploring Old Processes). This is a useful technique, because it produces not only a negative image, but also one of significantly higher contrast than the original. A third option is to use a colour transparency as the source image, and print it directly on resin-coated paper to give a negative print.

Whichever method is used for producing the print, the image should be carefully chosen. Simple images with distinct blocks of tone work best. Complicated pictures with lots of fine detail should be avoided. If you opt to produce your negative print by contact printing, remember that the final image will be left-to-right reversed, and you should flip the negative over in the enlarger if you wish to maintain the original orientation.

The print should be fixed and washed as usual and it is then ready for bleaching.

The etch bleach consists of two solutions which are mixed in equal proportions immediately before use. Their formulae are given below:

The component prints.

Holiday Slide On the printed page this may look like a simple view of a Kodak colour transparency, but do not underestimate the many days of hard work that went into making this 16 x 16 in (40 x 40 cm) print. Both components are hand-coloured monochrome images: the print of the slide mount was coloured using felt-tip pens; the inset print was coloured by airbrush using drawing inks and food dyes. Frisk masking film was used to define each coloured area.

Solution A		Solution B	
Copper sulphate	60 g	Hydrogen	
Citric acid	75 g	peroxide	20 vol.
Potassium bromide	4 g		
Water	to 500 ml		
The bleach is used hot, at 50°C (122°F) or more			

The print is immersed in the bleach. Very rapidly the image fades and the emulsion wrinkles and starts to detach from the backing

Kodachrome
SLIDE

PROCESSED BY KODAK

in the areas where there was originally tone. In order to remove the emulsion completely from these areas, the surface of the print is rubbed with cotton wool. This can either be done while the print is still in the bleach, or it can be removed and placed on a pile of newspaper. As you rub, the emulsion will gradually come away from even the finest areas of the print. You will find that in the unbleached areas, i.e. the original light tones, the emulsion is quite firmly attached to the backing. When the bleaching is complete, the print is rinsed to dislodge adhering pieces of scrap emulsion. It is then fixed and washed as usual.

At this stage the print looks like a completely blank sheet of paper, but if it is held obliquely to the light, the areas of emulsion can be seen in relief against the plastic backing of the resin-coated paper. This is the point at which the colouring can commence.

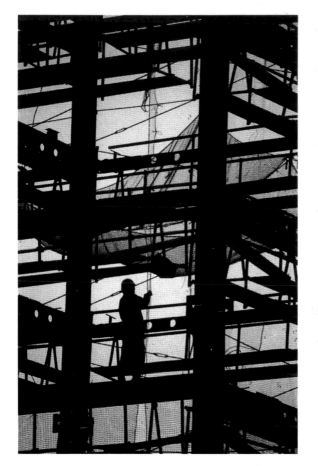

The straight print and its corresponding paper negative (*left* and *right*).

Any water-soluble dyes, paints, inks or pigments can be used, but some work better than others. Food dyes work well in my experience, and so do photo-tints, sold for retouching colour prints. The dye can be applied either by immersion or selectively to a moist print by brush or cotton wool. The colours are absorbed rapidly by the emulsion, but they do not even wet the surface of the plastic backing. When the colour has been applied evenly, the print is gently blotted with paper towels to remove the surface dye from the plastic backing, and the print is allowed to dry naturally. Do not attempt to wash the print at this stage; you will only succeed in removing the dye. On the other hand, if you do not like the colours you have applied, just wash the print thoroughly and start all over again.

Colour Construction Silhouette shots suit the etch bleach process and this picture of a construction worker, on site in Osaka, Japan, was an obvious choice. The high contrast straight print was used as a paper positive and contact printed to produce a paper negative. The etch bleach print was coloured by painting with photo-tints and food dyes of different colours. These were applied on wadges of cotton wool, and were allowed to run and merge into each other.

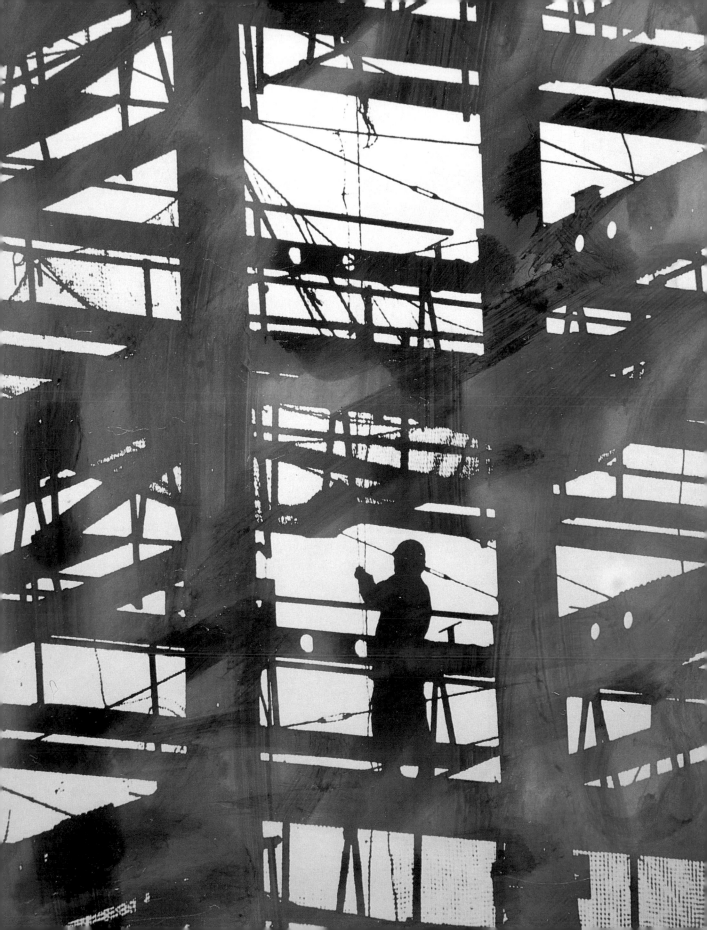

CHAPTER FOUR

LITH FILM

Lith film is a fascinating material to work with. It is an extreme contrast film, designed for use in the graphic arts industry, which is capable of reproducing images in black only, without intermediate grey tones. Because it gives a very sharp, dense image it has many applications in creative photography.

The name 'lith film' is something of a misnomer. It was presumably an abbreviation of lithographic film originally, but today the full name is rarely, if ever, used. True lithography is a mechanical printing process originating from an engraving on stone (the Greek word for stone is *lithos*). The techniques described in this chapter have nothing at all to do with true lithography, but are all concerned with the use of lith film to produce high contrast images.

Lith film is made by Kodak under the brand name Kodalith. It is available both as sheet film in a wide range of sizes and as 35 mm film. Sheet film is the more convenient form for creative photographic purposes, but it is very expensive and difficult to obtain in small quantities. At the time of writing, a box of 100 sheets of 10 × 8 in Kodalith cost between three and four times as much as an equivalent box of standard photographic paper.

Lith film is orthochromatic, which means it is sensitive to all wavelengths of light with the exception of red. This means that lith film must be handled under a deep red safelight.

When taken straight from the box, lith film is coloured bright red, but the colour quickly disappears once development begins. Any standard paper developer will produce an acceptable image on lith film, but without the extreme contrast normally associated with this material, and with some intermediate grey tones. In order to ensure that maximum possible contrast is obtained, with rich, deep blacks and clear whites, lith film should be developed in the specially formulated lith developer which is based on hydroquinone. The exposed film needs to be fully developed and then fixed in a standard paper fixer.

Lith film is very slow, compared with conventional panchromatic films, which are sensitive to all wavelengths of light – it has a film speed of about ISO 5. It is not really suited for use in the camera and is more of a darkroom tool. Using it in the camera to photograph normal subjects can give some very disappointing results, on account of its very high contrast and the difficulty of predicting the correct exposure. All detail is usually lost in both highlight and shadow areas of the negative, and it is not easy to envisage what the result will look like when the photograph is taken. It is, therefore, better to photograph the original scene using conventional black and white film, or even colour film, and copy the negative on to

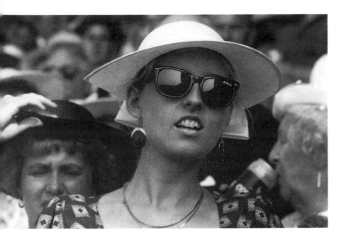

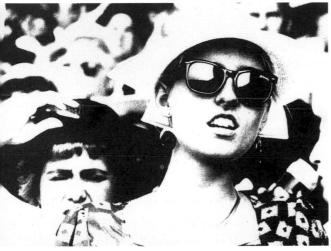

A lith positive (*lower left*) was made by enlarging the negative to 10 × 8 in (25·4 × 20·3 cm) on a sheet of lith film to give a high contrast image, which emphasized the graphic qualities of the main subject, but which made the background confusing. A straight print (*left*) is shown for comparison. In order to remove the background, the shape of the figure was masked on the lith positive using Frisk masking film (see Chapter Three – Introducing Colours). The sheet film was then 'blocked out' by spraying it with a car touch-up aerosol. Any colour will do. When the paint had dried, the masking film was removed and the retouched lith positive contact printed on a further sheet of lith film to produce a lith negative with clear film for a background. The lith negative and the retouched lith positive, being a matching pair, were each printed on paper and then mounted side by side on the same sheet of card to produce the final print below.

Mirror Image

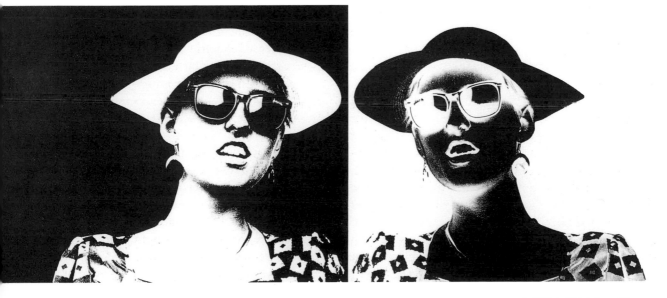

lith film in the darkroom. This allows as many attempts as necessary to get the result right without risking the loss of important highlight or shadow detail, which safely remain on the original negative.

Copying a negative – or for that matter a transparency – on lith film can be achieved either by contact printing or by enlargement. For contact printing, the negative and lith film must be kept in close contact with each other, and a contact printing frame is invaluable. Alternatively, a sheet of glass can be used, but the principle is the same. Place the negative on the unexposed lith film so that the two emulsions are in contact, lay the glass on top, and expose the combination to light through the glass. Any controllable light source is suitable, such as an enlarger or flashgun.

Any exposure is effective for only a part of the tonal range of the negative, and some trial and error is likely to be necessary before the correct exposure is achieved. The result is best judged in the main subject areas of the image, for example in the face of a portrait, and you will often find that much detail is lost in other areas of the image. This is characteristic of lith film, and with experience you will be able to recognize what an acceptable lith positive or negative looks like.

With a conventional black and white film or print, any increase in the exposure produces a darker image. Areas which were light grey become mid-grey; dark grey tones approach black. As lith negatives and positives are characterized by dense blacks and very clear whites, with no intermediate tones at all, the result of an increase in exposure is to convert some of the white areas straight to black. This is seen as a change in the relative proportions of black to white with longer exposures giving a larger area of black. Exposure, therefore, determines not only the overall density, but also the shape of the lith image, and even a slightly wrong exposure can change the shape sufficiently to destroy the intended effect.

One problem you are sure to encounter with lith film is the appearance of 'pin holes' – small clear spots in the emulsion caused by dust. I am not aware of any satisfactory way of avoiding them; they seem to appear even when you are being scrupulously clean. The smaller the size of lith film you use, the larger the relative size of the spots, so the answer is perhaps to use large sheets of lith film, if you can afford them. Once they have appeared, 'pin holes' can be blocked out on the film by using photographic opaque – an orange, water-soluble paste, which can be applied with a fine brush or cocktail stick. If applied wrongly, it is easily removed by rinsing the negative.

An image can be produced on lith film from any photographic source: black and white negative; colour negative or colour transparency. It does not matter whether the original is a positive or negative because a lith image can readily be contact printed to produce the reverse image. For example, contact printing a black and white negative on lith film produces a lith positive; contact printing this lith positive on further lith film results in the corresponding lith negative. This process can be carried out whenever and as often as necessary to produce the desired effect. Many lith techniques require the use of both positive and negative images, and interconversion between one and the other becomes second nature.

The secret with lith film is to play with it. Experiment by copying various negatives and transparencies at different exposures and see what happens. You may find some surprises or you may quickly fill your rubbish bin!

Positive and Negative A lith positive was printed 21 times on paper and these prints were mounted together with a single print made from the corresponding lith negative. The result relies more on the creative mounting than on the original subject for its pictorial effect. The final touch was to rephotograph the montage so that the entire image is on a single negative to allow several prints to be made.

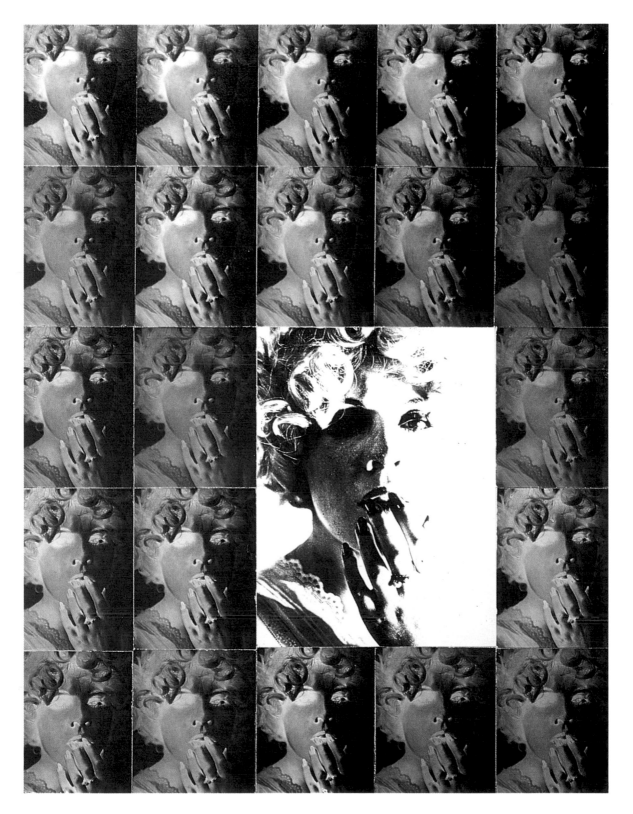

LINE CONVERSION OR BAS-RELIEF

If you take a lith positive and a corresponding lith negative, both of the same size, and sandwich them together exactly in register, emulsion-to-emulsion, they cancel out each other. Clear areas in one piece of film coincide with black areas in the other and the net result is a completely dense sandwich which blocks out all the light.

If the two elements of the sandwich are now moved slightly out of alignment, some of the clear areas on one film will overlap some of the clear areas on the other, allowing light to pass through. The sandwich can now be used as a negative for printing.

As the positive and negative are moved only slightly out of register, it is only at the edges of the original blocks of tone where light can pass through the sandwich. This gives a fine line effect when the sandwich is printed, with black lines on a white background, rather like a drawing or a bas-relief carving. The image is a strange composite in which some areas appear positive whilst others appear negative.

A bas-relief image cannot itself be considered either as a positive or as a negative since it is derived from both. Nevertheless, for each bas-relief, an equivalent image in reverse can be created by contact printing on further lith film. To all intents and purposes the two bas-reliefs appear as a matching positive–negative pair. This opens up a whole new world of creative possibilities. By printing this pair of images

The straight print

slightly out of register a second generation derivative can be produced. This procedure can be repeated to produce a third generation derivative, and so on.

A further creative possibility with this technique is to allow one component of the positive–negative pair to retain some intermediate grey tones. This is achieved by using a less contrasty or more dilute developer. The result is a bas-relief which contains partial mid-tones.

TONE LINE

Tone line is a similar technique to bas-relief. Both are produced by printing a sandwich

consisting of a lith positive and a lith negative. The difference is that in a bas-relief the pieces of lith film are emulsion-to-emulsion and out of register, but in a tone line they are back-to-back and in register.

The principle of tone line is that the emulsions of the two lith images are physically separated by the translucent film base and this allows light to diffuse around the blocks of tone and produce an image – even when the sandwich is accurately registered. The sandwich is contact printed on lith film using a contact printing frame and an oblique light source. In practice this is achieved by holding the contact printing frame at a steep oblique angle to the light beam from the enlarger and rotating the frame continuously to make sure the light penetrates in all directions.

Stone Gables The completed bas-relief of an old building in Stirling, Scotland.

The original picture This grab shot was an instantaneous response to spotting someone I identified as the cartoon character, Andy Capp, appropriately juxtaposed with a sign about racing complaints. Unfortunately, there was no time to check the camera was correctly set before shooting and the negative is very underexposed and thin. This was the reason I sought some alternative means of making an acceptable print.

Andy Capp The completed tone line image appropriately bears some resemblance to a comic strip cartoon, and to reinforce this message I included the edge of the negative to form a surrounding box.

LITH MASKS FOR COLOUR TRANSPARENCIES

This is a technique which looks complicated but isn't. It simply involves contact printing a colour transparency on lith film and sandwiching the resulting lith negative with the original transparency, exactly in register. It's as easy as that. A lith negative used for this purpose is referred to as a lith mask.

At best the resulting picture is unrealistic. At worst it is weird, because where the light tones are expected in the picture they are superimposed by the dense black of the lith film. This is a technique for use on selected transparencies only, but the only way to discover whether it works is to try it.

The procedure for making lith masks is exactly the same as that described for contact printing black and white negatives. As before, the amount of black on the mask is controlled by adjusting the exposure during contact printing.

The original colour transparency *(left)* is relatively unexciting with flat lighting. However, its flatness makes it suitable for contact printing on lith film to produce a lith mask *(right)*.

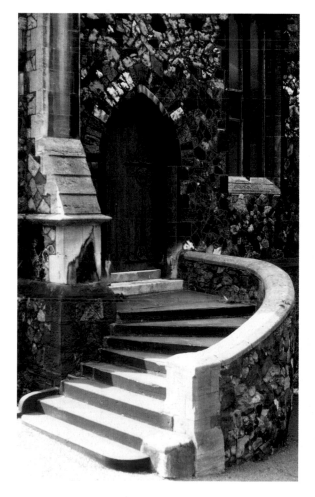

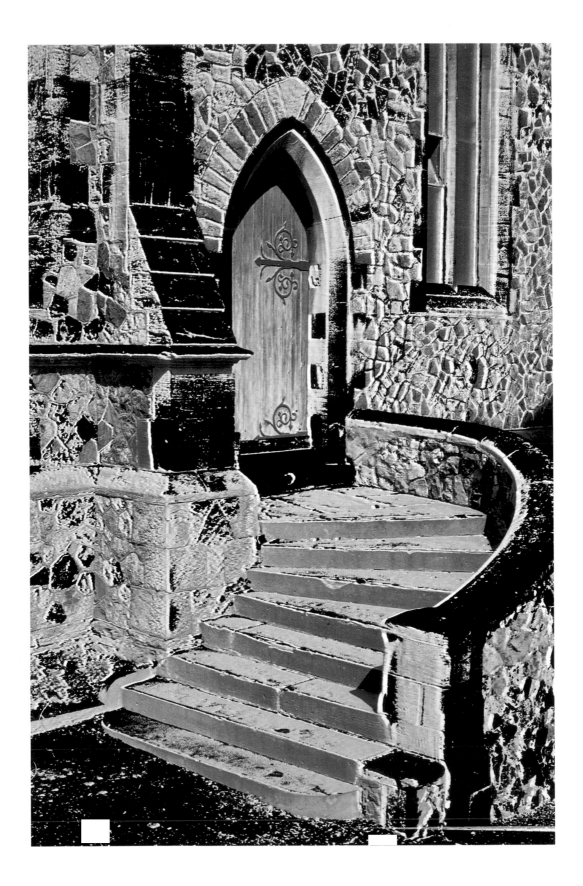

Modified Lith Masks

By the very nature of the lith mask technique, every light tone in the picture is superimposed by the dense black of the lith film. There may, however, be occasions where a particular area of light tone is crucial to the picture and would be destroyed by the use of a lith mask. In such cases it is possible to manipulate the mask so that selected areas remain unchanged.

To do this involves a little time, patience and photographic opaque. The procedure for altering a lith mask, taken step by step, is as follows:

Stage 1 Contact print the transparency on to lith film to give a lith mask as usual. The light-toned subject of the picture appears on the mask as a black area on clear film.

Stage 2 Contact print the lith mask on a further sheet of lith film. The main subject now appears as a clear area on black.

Stage 3 Using a fine brush, apply photographic opaque to the emulsion side of the film to block out the clear area corresponding to the main subject. Allow the photographic opaque to dry.

Stage 4 Contact print the retouched film on more lith film. The resulting lith mask is identical to the original mask, i.e. the black areas correspond to the light tones on the original, except that there is no black corresponding to the treated area.

Stage 5 Bind the modified lith mask in register with the original slide to produce the final picture.

South Door The final picture, created by binding together, exactly in register, the original transparency with the lith mask illustrated on the previous page. The result is unusual and unreal.

The original colour transparency

The straight lith mask

The modified lith mask

The lith mask with the photographic opaque applied

A Word About Registration

A major problem with many techniques involving lith film is ensuring accurate registration of the component pieces of film in a sandwich. The problem can be minimized by using large sheets of lith film because the likely error in accurately positioning two 20 × 16 in sheets of film is obviously much less than dealing with two tiny pieces the size of a 35 mm negative. The drawback to working at this size is the high cost of lith film. Also, there is no point in using huge sheets of film for a picture to be used in a 35 mm projector. What is needed, therefore, is a way of guaranteeing accurate registration on a small scale.

The truth of the matter is, it's difficult. Good eyesight and a magnifying glass help. When using 35 mm film, be sure not to crop off the image of the sprocket holes, as this is an invaluable aid for registration. Using a light box and a magnifying glass, align the sprocket holes at two diagonally opposite corners of the two pieces of film as accurately as possible and fix them together with tiny portions of adhesive tape on the rebate of the film.

If registration is likely to be a regular problem, you can make a jig corresponding to the size of film you use. A jig is essentially a contact printing frame with some means of ensuring that pieces of film can repeatedly be placed in exactly the same position. One way of achieving this is to fix a small, sharp pin at opposite corners of the jig, to coincide with the rebate of the film. The jig can be used both for contact printing and for binding up sandwiches. To use the jig for contact printing, pierce both components of the sandwich on the pins and leave them in position during the exposure. For binding, reposition the two components on the pins and bind them together with adhesive tape. They will now be in exact register.

Homeless A straightforward lith mask superimposed on this picture fails, because it obliterates the main subject – the Arab lady and her child. The lith mask was modified, therefore, using photographic opaque.

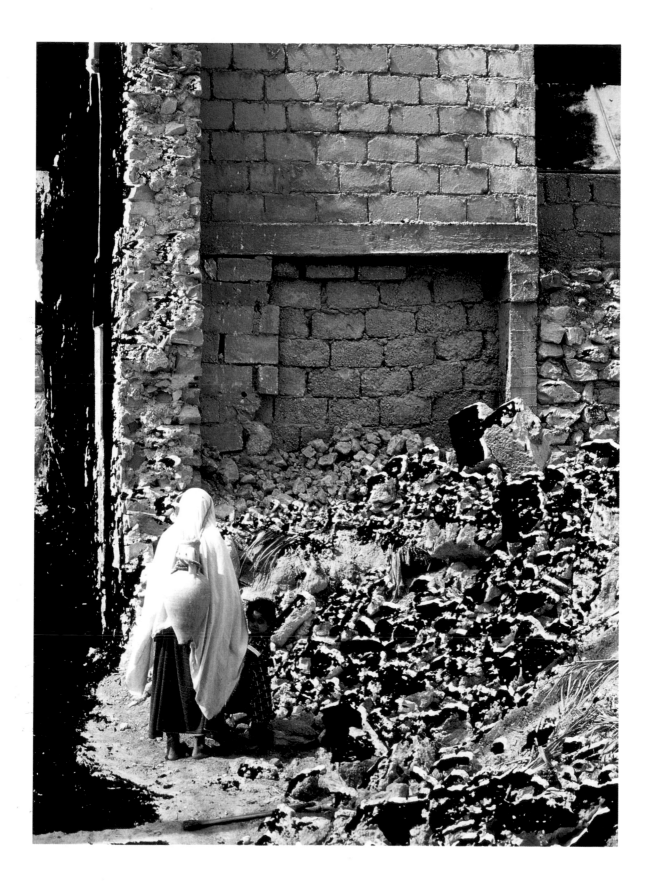

SOLARIZATION (THE SABATTIER EFFECT)

Originally the word solarization referred to an effect which occurred when an emulsion was grossly overexposed, causing the image to be partially or completely reversed. The word continues to be used, albeit incorrectly, for a similar technique which, strictly speaking, should be called the Sabattier Effect. It is this second use of the term which is described in detail below.

Solarization is a fascinating technique which is likely to give hours of entertainment in the darkroom, not to mention frustration. It is based on a strange chemical phenomenon which occurs when a partially developed emulsion is re-exposed to light. Both film and paper can be solarized, but the best effects are obtained with lith film. To perfect the technique takes patience, trial and error and a lot of sheets of lith film.

When a lith negative containing a white image on black is printed normally, a lith positive is formed which has a black image on white. If the lith positive is solarized, by turning the light on during development, the result is a black image with a white line around it, on a black background.

To understand how and why this happens involves some chemistry. The reason the emulsion of a black and white film is sensitive to light is that it contains grains of silver bromide or some other silver halide. When exposed to light, the silver ions are sensitized and form a latent image. This can be developed by allowing the silver ions to accept an electron to form metallic silver:

$$Ag^+Br^- + \varepsilon^- \longrightarrow Ag + Br^-$$

Photographic developers all contain reducing agents capable of donating an electron. During development, bromide ions are formed as a by-product and these are dissolved away in the developer.

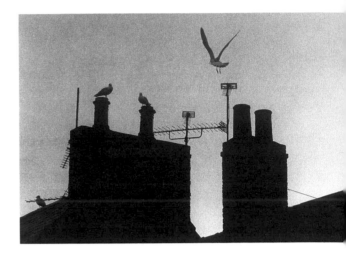

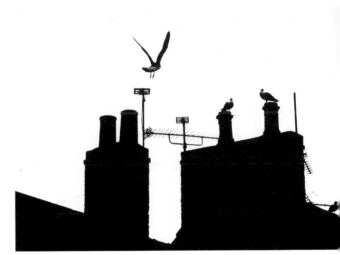

A straight print (*top*) of a shot taken in dull lighting is rather grey in appearance. Converting it to a lith positive (*above*) immediately produces a crisper, brighter image with a sharply defined outline, which makes it suitable for solarization.

Rooftops This solarization was made by contact printing a lith negative on lith film, using an initial exposure of 30 seconds at f22. After development for 30 seconds, a second exposure was made to white light, with the enlarger set at 40 seconds at f11, without removing the film from the developer. Development was continued, without agitation, for a total of four minutes. The solarized film was then printed in order to show the image as a black line on a white background.

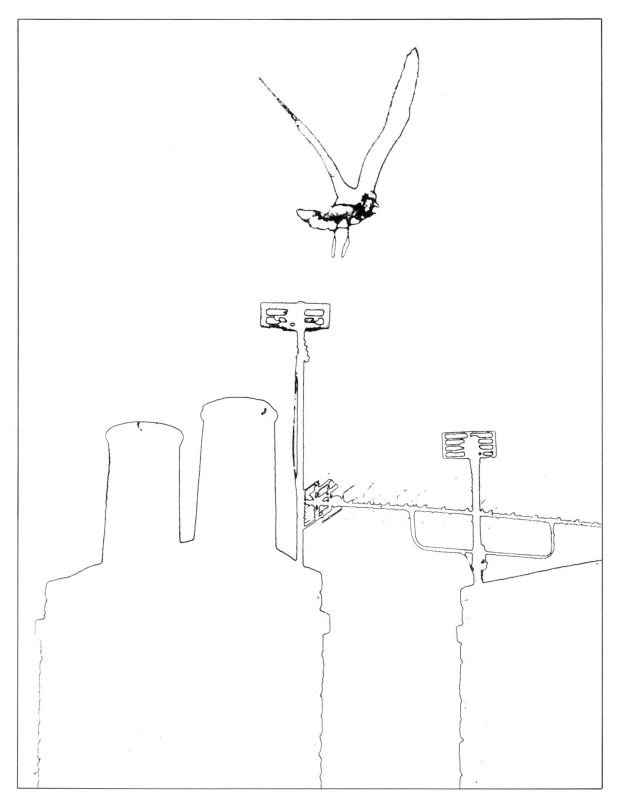

So far the image is unstable, because unreacted silver ions are still present in the highlight areas which were not exposed to light. These are capable of responding to further exposure to light unless the film is fixed. The basis of fixer is sodium thiosulphate which reacts with any residual silver ions to form silver thiosulphate, which is soluble and dissolves away in the fixer. This is the situation when a film or paper is exposed, developed and fixed normally.

To make a solarization, a lith negative is first contact printed on lith film. This initial exposure sensitizes the emulsion as usual and forms the latent image. The film is placed in the developer and agitated as normal until the image starts to appear. Up to this point the chemistry is standard: silver ions are converting to metallic silver and bromide ions are being formed.

Instead of allowing the development to proceed to completion as normal, the film is now re-exposed to white light, which sensitizes the unexposed silver ions in the highlight areas. As development continues, the highlights start to darken as the freshly exposed silver ions convert to metallic silver. This is the point at which the strange phenomenon occurs: the bromide ions, as they form, migrate away from the newly developing silver ions, until they meet the already developed image from the first exposure. In other words, they move to the boundary between the original highlight and shadow areas. There they accumulate, and this inhibits further development in these areas.

The net result is that the shadow areas are black from the first exposure; the highlight areas are black from the second exposure and there is a thin white line between the two. This line is known as a Mackie line, after the man who first discovered it. The solarized image is neither positive nor negative and the same result is obtained whether a lith positive or a lith negative is used.

The solarized image is fixed and washed as usual and it can then be printed to give a black line image on a white background.

The length of each exposure will need to be determined by trial and error, as will the point during development at which the second exposure is given. The second exposure can be made without removing the film from the developer, by placing the developing dish under the enlarger and exposing without a negative in the carrier. Any movement in the dish should be allowed to cease before the second exposure is made, and afterwards agitation should be kept to a minimum. As for any lith work, a red safelight is used which may make it difficult to see any line at all during development. Be patient: you may have a pleasant surprise when you hold the fixed film up to the light.

The most suitable type of image for solarization is one where the subject is clearly defined in one tone against a background of the other; in other words, a distinct black image on white or white image on black. Silhouettes work well.

Solarization can be performed on paper as well as on lith film, indeed more easily so, but the Mackie line will be less sharp, less distinct and grey. It may not even occur at all. Solarized prints often just look fogged and disappointing.

TONE SEPARATION OR POSTERIZATION

Tone separation, also known as posterization, is more difficult to describe than to carry out. Whilst time-consuming, it is at least fairly easy, provided you are able to assure accurate registration of two or more negatives.

It might help to start off by thinking of a lith negative as the ultimate tone separation consisting of two distinct tones, one being black and the other white. By comparison, a conventional black and white negative contains a continuous range of tones, from black, through all the tones of grey, to white. A tone separation falls midway between a full-tone

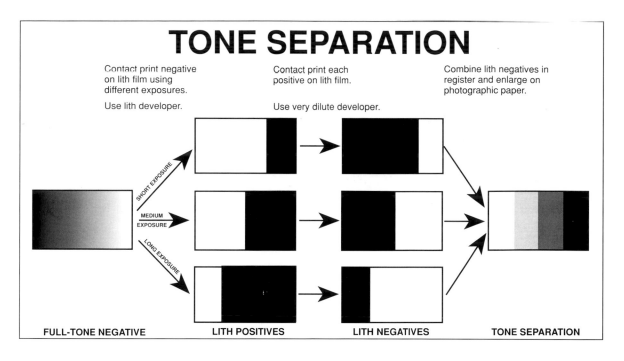

TONE SEPARATION

Contact print negative on lith film using different exposures.

Use lith developer.

Contact print each positive on lith film.

Use very dilute developer.

Combine lith negatives in register and enlarge on photographic paper.

SHORT EXPOSURE

MEDIUM EXPOSURE

LONG EXPOSURE

FULL-TONE NEGATIVE **LITH POSITIVES** **LITH NEGATIVES** **TONE SEPARATION**

negative and a lith negative. It contains intermediate tones, but they are step-wise rather than continuous. In other words, it contains black, a discrete number of distinct tones of grey, and white. The simplest tone separation, therefore, contains three distinct tones: black, grey and white. A further tone can be added to give a four tone separation with black, dark grey, light grey and white. Any number of tones can be used in tone separation, but each tone is uniform and quite separate from the others.

To produce a tone separation it is necessary to use more than one lith negative. The first one gives two tones and each additional negative adds one further tone. It follows, therefore, that a tone separation containing four tones requires three separation negatives, and so on. Each negative is responsible for only part of the tonal range in the final tone separation, but together they account for it all.

How, then, do we make a tone separation positive from our full-tone negative? Essentially there are three stages, illustrated in the diagram above. Let us assume we are making a four tone separation.

Stage 1 Contact print the chosen negative three times on different sheets of lith film, using three different exposures. The exposures should be sufficiently different to produce quite different amounts of black when developed. The aim is for the lightest negative to contain the shadow detail, the darkest negative to contain the highlight detail, and the middle negative to contain the intermediate detail. Develop the film as usual in lith developer to give as dense a black as possible. The three pieces of developed film are then used as the tone separation positives.

Stage 2 Contact print each of the tone separation positives on further lith film to give the corresponding tone separation negatives. This time, instead of using lith developer, use a very dilute print developer. A suitable degree of dilution may be 1 in 30, but the exact dilution is not critical. The resulting negatives have exactly the same proportions of black and white as they would have had if developed in lith developer, but instead of a dense black they have a transparent, fairly light grey tone.

Stage 3 The three tone separation negatives are now bound together, exactly in register. Because the darkest tone in each negative is no more than a pale grey, the resulting sandwich, when held up to the light, shows four separate tones:

- A black tone where all three negatives are black;
- A dark grey tone where two negatives are black and one is clear;
- A light grey tone where one is black and two are clear, and
- A white tone where all three negatives are clear.

The tone separation sandwich is then simply printed as for any conventional, full-tone negative.

The original, full-tone print (*below*)

The two separation positives (*opposite top*)

Splash! (*opposite bottom*) A simple tone separation using only two separation negatives, giving three distinct tones: black, grey and white.

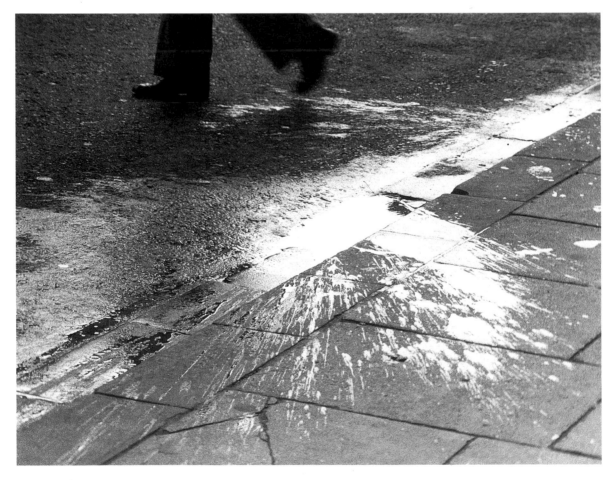

CHAPTER FIVE

EXPLORING OLD PROCESSES

Nothing fundamental has changed about photography since it was first discovered by Fox Talbot in 1839. Images are still produced by what now seems a primitive process involving the chemical reaction of silver salts with light and 'wet' development. Although we now have more sophisticated equipment, higher quality materials and more efficient techniques, the basic process is unchanged. This means that many of the methods used in the past can still be applied today, even though they may not now be in common use. There is no longer any need to mix our own emulsions, coat our own plates or get our hands dirty, but if we really want to go back in time, we can.

If you take a look at Victorian photographs, they look different from modern ones, and this is not entirely due to the presence of horse-drawn carriages and long skirts. The difference is also due to the use of old processes which are now obsolete; a pity since they often had a quality of their own which cannot be reproduced by modern materials. These time-consuming, messy processes no longer have a place in present day applications and have been replaced by automated, more efficient and reliable methods.

Because of their very nature, old processes often relied on artistry as well as photography to achieve their effect. Skill was needed in

brushwork to apply an emulsion or a pigment, and this led to its own creativity. The early users of photography were, in fact, often painters discovering a new medium, and this is reflected in their work. Early photographers such as Daguerre, David Octavius Hill and Roger Fenton were painters by profession. Others understandably emulated painters, because paintings were the only source of visual art available at that time to give inspiration. They no doubt also wished to be considered artists rather than technicians. It is, therefore, no surprise to find that early photographs often resemble paintings.

As photography became established as an artistic medium in its own right, and became easier, it was opened up to those without formal art training and the nature of photographs changed. They took on a more realistic, factual character and photographers started to exploit the artistry inherent in the photographic process itself rather than treating it as a form of painting.

Nowadays, photography bears little resemblance to painting. Indeed, it is difficult, using modern materials, to produce a photograph which looks like a painting, and it might be necessary to resort to the old processes if this is the effect you require.

There are plenty of old processes to choose from and this gives considerable scope for

creative photography. You may need to discover for yourself how to proceed, and there may be no one to consult in the event of problems, but this is all part of the enjoyment. The old masters were themselves pioneers, and they seemed to manage perfectly well. At least you have the advantage of countless old books of photographs to refer to, many of which describe in some detail how the old masters worked.

This chapter sets out to describe a few of the old processes which I have personally found useful for executing specific ideas.

PAPER NEGATIVES

Paper negatives are exactly what their name suggests – negatives made on paper rather than film. They were once used as a cheaper alternative to film-based negatives: for example they were used for 'while you wait' photographs and for free films such as the now obsolete Gratispool. Traditionally, paper negatives were printed either by transmitted or reflected light, or by rephotographing them on a similar sheet of paper.

Quite apart from the original use of paper negatives in the camera, they continue to be useful as a darkroom tool. They can be made from conventional film-based negatives, either by contact printing or by enlargement. A paper negative so made is printed in exactly the same way as a conventional negative, by passing light through it to form an image on a sheet of printing paper. This is possible because, whilst the paper negative appears opaque when viewed normally, it is translucent when held up to the light.

Paper negatives are made on ordinary bromide paper in exactly the same way as a print. They are made to the full size of the final print and then contact printed. In so doing, not only the image, but to some extent also the texture of the paper, is conveyed to the final print.

Paper negatives are useful in several situations. If a straight print is too sharp and crisp, using a paper negative has the effect of softening the edges of the image somewhat. The result is a more diffuse impression. Paper negatives are also a useful way of drastically increasing contrast in a picture. They also have the advantage that, being paper-based, they can be extensively retouched, giving considerable control over the final effect.

To make a paper negative, enlarge the chosen film negative on a sheet of paper of the size intended for the final print and develop it as usual. The softest possible paper grade should be used, because each step of the paper negative process results in a dramatic increase in contrast. Grade 0 paper is ideal if you can get it. If any printing control is needed, such as burning or dodging (see page 25), this should be carried out during the production of this initial print or paper positive. A good paper positive looks grey and muddy. If it looks even half-way acceptable, you have probably made it too contrasty.

The paper positive can be retouched at this stage, if necessary. Selected areas of the image can be darkened by appropriate artwork, using any means which will add tone to white paper. The added tone does not have to be grey or black; nearly any colour will do, since the artwork will be transferred to the next stage in the form of a silver image. For a start you could experiment with pencil, charcoal, ink, paints, felt-tip pens, airbrush … virtually anything. But, avoid the temptation to use typewriter correction fluid to remove areas of tone. It has the effect of darkening the final print, because the image is transferred by transmitted light. If any areas do need to be lightened, this is done at the next stage.

Now, contact print the paper positive by placing it, emulsion-to-emulsion, on top of a second, unexposed sheet of paper of the same size and grade. A heavy sheet of glass, an inch or two larger all round than the paper, keeps the two in intimate contact. Expose through

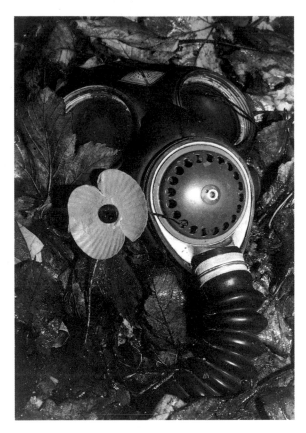

The straight print (*left*) The basis of this picture was the visual link between the paper poppy – worn in remembrance of the soldiers who died in World War I – and the gas mask, which is similar to those worn by the soldiers. I wanted to create the impression that the gas mask had lain buried and forgotten for decades, but the results were disappointing – the gas mask looked too new. Somehow the image had to be degraded, so that the subject looked old and neglected. The paper negative technique was the answer.

The paper positive (*below left*) A very soft print was made on Grade 0 paper, which was about ten years old and hence had reduced even further in contrast. The print was then retouched, using charcoal and a 6B pencil, to obliterate the manufacturer's name, tone down the shiny highlights on the gas mask, and subdue the effect of newness.

The paper negative (*below*) This is the corresponding negative, made by contact printing the paper positive. It was also retouched as above to lighten certain areas.

Remembrance In the finished print (*opposite*) the paper texture can clearly be seen and, despite using Grade 0 paper, the contrast has built up. The print was sepia toned to create the impression of decay and the poppy was hand-coloured using a red felt-tip pen.

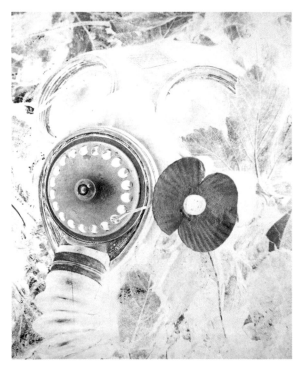

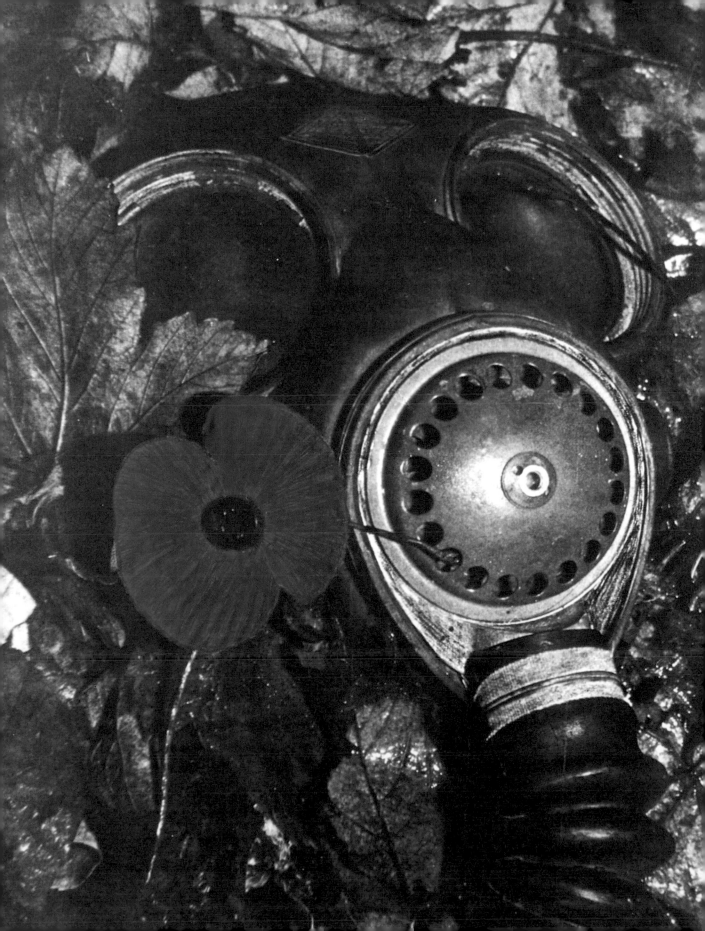

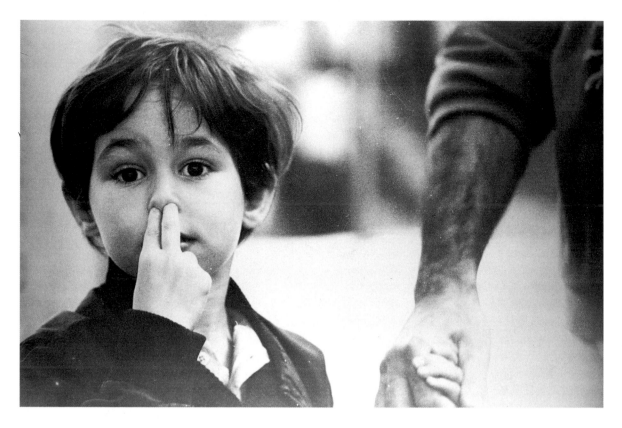

The paper negative (*below*) The Grade 5 print was contact printed on a sheet of Grade 1 paper to produce this paper negative. Already a definite increase in contrast is evident. The unattractive, harsh background is unfortunately very distracting, but this was not a problem, since it was an easy matter to retouch it on the paper negative.

The retouched paper negative (*below*) The paper negative was first covered with Frisk and the areas relating to the background cut away with a scalpel, so that the main subject remained protected by the film. Next, the whole print was sprayed with aerosol paint, until it was almost obliterated and the masking film peeled off, to reveal the retouched paper negative.

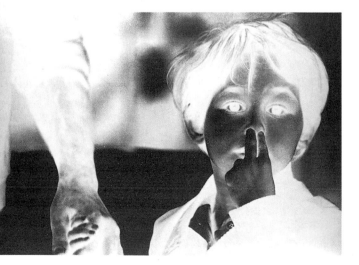

The straight print (*opposite*) As soon as I saw this boy, I shot spontaneously, but my camera was not set for the right exposure and the negative is many stops underexposed. There was no time for a second shot. This was the highest contrast print I could make, using Grade 5 paper. Even so, it is still very grey and dull. It was, however, ideal for use as a paper positive.

Salute (*below*) Compare the finished print with the straight print made on Grade 5 paper. The paper negative technique has enabled a print to be made many grades harder and, in the process, the background has also been 'tidied up'.

the back of the paper positive by turning on the room light or by exposing to white light from the enlarger. The exposure will be a long one – five or ten minutes or more – depending on the thickness of the paper positive. Develop the exposed sheet of paper and you now have the paper negative.

The paper negative will be of significantly higher contrast than the paper positive. Not only the image but the artwork should be evident now. Further retouching can be carried out on the paper negative, using the same materials as before to add tone. This time, however, as the image is negative, the effect is to lighten the final image.

Contact printing the paper negative on yet another sheet of soft paper produces the final print. Quite apart from the effect of any specific artwork, the image on the final print is a little less sharp than a print made directly from the original negative.

Some trial and error is needed to establish the contact printing exposures at each stage. Also, it is possible to vary the grades of paper used to give exactly the right degree of contrast in the finished print. Double-weight paper can be used to give a particularly evident fibre texture from the paper itself; the effect will be less pronounced on single-weight paper.

BROMOIL

Of the old pigment processes, bromoil was perhaps the most popular, though few photographers work in this medium today. Essentially, it is a means of replacing the conventional silver image of a black and white print by an oil-based pigment. The resulting print bears some resemblance to an etching or lithograph and has a lovely granular quality, which derives as much from the brushwork as from the image itself.

Bromoil is a technique well worth pursuing for the effect it produces, but it is messy and time-consuming. It requires a degree of artistry

The original black and white print used as the basis for the bromoil shown opposite.

Tying Up (*opposite*) The finished bromoil has a soft, granular quality which resembles a lithograph.

in the brush strokes, as well as traditional darkroom skills. A certain amount of patience helps too.

Four basic items are needed for bromoil – printing paper, bleach, brushes and pigments. Unfortunately, the special equipment and materials necessary for bromoil are no longer available. Unless you are lucky enough to have the brushes and materials bequeathed to you by an old bromoil worker, you will have to make do with whatever materials are available. Having said that, there are excellent substitutes

for all the equipment and materials, even though they may not be specifically sold for the purpose of bromoil printing.

The paper The printing paper used for bromoil must be absorbent and capable of receiving the pigment. Modern glossy papers, and particularly resin-coated papers, are unsuitable for this purpose. As far as I am aware, the only type of paper still available which is suitable for bromoil is British-made Kentmere Art, which is available under the Luminos Corporation label in the USA.

The bleach A special tanning bleach is required which selectively hardens the emulsion as it bleaches the image, in proportion to the density of tone in the original print. Fortunately, this can be made to the original formula given below:

Bromoil bleach	
Copper sulphate	30 g
Potassium bromide	30 g
Potassium dichromate	1.5 g
Sulphuric acid	1.5 ml
Water	to 500 ml
Dilute 1 + 3 with water for use.	

The brush If you manage to get hold of a set of the special bromoil brushes, be sure to hang on to them. You may not get a second chance. They are large, round bristle brushes, with the bristles cut to a flat but sloping surface. The bristles are made from hog hair or pole cat fitch, and each brush is used for a different purpose. The characteristic shape of the brushes is designed to give the correct brush strokes which are very important to the appearance of the finished bromoil picture. In the absence of real bromoil brushes, the best substitute is probably a shaving brush with its bristles cut to a flat, oblique surface.

The pigment You may be lucky enough to find some old Sinclair bromoil pigments, but it may be asking too much to expect that they will still be in good condition. The advantage of the original pigments is that they were made in different hardnesses, which is important for introducing subtle tones in the bromoil. Nevertheless, if you cannot obtain them, you can make do with oil-based pigments such as printers' ink or oil paints.

Once you have assembled all the necessary materials, how then do you proceed to make a bromoil print?

First, make a conventional monochrome print on Kentmere Art paper and fix it in plain hypo. An approximately 10–15% solution of sodium thiosulphate in water will do. If you use a standard acid hardening fixer the emulsion may not absorb sufficient water for the technique to work properly. Wash the print thoroughly.

Immerse the print in the tanning bleach. After a few minutes, nothing but a pale residual image remains. The differential hardening of the emulsion which occurs is not visually obvious. In the shadow areas, which originally contained the darker tones, the bleaching hardens the emulsion. The highlights, however, which contained little tone, are unaffected in this way, and the emulsion remains unchanged as soft gelatin. The intermediate tones harden proportionally to their density. This differential hardening of the emulsion forms a latent image and is the key to the bromoil process.

The next stage is to prepare the print – or matrix, as it is known after bleaching – for pigmenting. This involves soaking the matrix in water for several hours. This causes the soft areas of emulsion to swell and absorb water. The hardened areas are unaffected. The end result is a matrix which is waterlogged in areas corresponding to highlights in the original

Burial on the Mount of Olives Another example of a bromoil print.

image and has a low water content in the original shadow areas. At this stage, the appearance of the matrix is as a sodden sheet of paper with almost no image.

The basic principle of bromoil is that water repels oil. The emulsion of the matrix now has a differential water content in inverse proportion to the tones in the original image. This aquatic latent image is therefore capable of repelling or receiving an oil-based pigment according to water content.

The next operation is the messy part of the process and is carried out on copious layers of newspaper. The waterlogged matrix is removed from the soaking bath, blotted to remove the surface water and placed on the newspaper. It is now ready for pigmenting.

Using the hog hair brush, coat the entire surface of the matrix as quickly as possible with the oil-based pigment. It will look a mess at this stage. Now starts the artistic part of the process, because skill in applying different brush strokes will determine the final result. Individual brush strokes have pictorial names such as 'hopping' and 'pouncing', which give an indication of how the brush is used. The general idea, though, is to work systematically over the pigmented surface of the matrix with the pole cat fitch brush. In so doing, a strange phenomenon occurs: the pigment adheres to the hardened areas which contain little water, but where the brush comes into contact with soft emulsion, now swollen with water, the pigment is repelled and the brush simply skates across the surface.

In due course, with continued brushwork, the pigment builds up on the hardened areas – where originally there was tone – and is gradually removed from the highlight areas. In this way the original image reappears, only now in oil-based pigment rather than in silver.

In an extension of this process – bromoil transfer – the pigment can be transferred to a fine art paper. This is achieved in a press and produces a more permanent image.

GUM BICHROMATE

Gum bichromate is a pigment process based on the ability of bichromates to react with colloids to produce a light sensitive complex. When exposed to light this complex becomes insoluble in water, but is soluble otherwise. If a water-soluble pigment is added to the mixture, an interesting and versatile photographic emulsion is formed. When coated on a sheet of paper, image making can begin.

The starting point for a gum bichromate is not a conventional silver based print as for bromoil, except that a full-sized film or paper negative is necessary. The final image is, however, on non-photographic paper. Therefore, the photographer has some choice over the surface, colour and texture of paper used. This adds to the effect of the finished piece of work.

The emulsion is made by mixing three ingredients: gum, bichromate and pigment, and coating it on a suitable paper. You will need the following materials:

The gum The gum involved is gum arabic, which in its raw state takes the form of tear-shaped lumps of hard, glassy exudate obtained from the trunk of the acacia tree. A mucilage is made by suspending the gum arabic in water in a muslin bag. This has traditionally been made up as required by gum bichromate workers but gum arabic is only slowly soluble in water and it can take a matter of days to produce. If you really do wish to do it this way, then make up a 25–30% solution, keep it refrigerated and use it all within a few days because, being a natural substance, it is prone to microbiological contamination. If you prefer to make life easy for

After the first exposure The lighter colour (vermilion) was the first to be printed (*opposite bottom*) and this was associated with the highlight negative (*opposite top*) using an exposure of three hours to fairly dull daylight.

The shadow negative The second emulsion was coloured by an approximately 3:1 mixture of vermilion and ivory black and was exposed to the shadow negative (*opposite top*) for about one and a half hours to dull daylight.

The original colour transparency (*opposite bottom*)

Crystal Gazer (*below*) This gum bichromate is also a tone separation (see Chapter Four – Lith Film). Two full-size separation negatives were made on lith film from the original colour transparency and were printed sequentially on the same sheet of paper. The paper was coated with a separate emulsion before each exposure, each of a different colour, albeit a different tone of the same hue. The exposed paper was developed by floating it, face down, in still water for about three and a half hours.

yourself, go to your local artists' supplies shop and buy a bottle of ready-prepared gum arabic, as used by water-colour artists. This is preserved, so it can be kept and used as required.

The bichromate The usual bichromate is potassium dichromate (bichromate and dichromate mean the same thing, but the former term is now antiquated, which shows how old the process is). Sodium dichromate and ammonium dichromate are both suitable alternatives. Make a saturated solution of the bichromate you choose to use. For potassium dichromate, this is about a 10% solution. There is no need to measure the concentration accurately; just keep adding bichromate to warm water until no more will dissolve and undissolved crystals are present at the bottom of the solution.

Best Foot Foward A gum bichromate print made from a single negative. The pigment used was a mixture of equal parts of Cerulean blue and ultramarine water-colour paints. The water-colour paper was first given an overall wash of cadmium yellow paint and allowed to dry before coating the emulsion. The image was transferred from a paper negative printed on resin-coated paper with the emulsion stripped from its backing to reduce the thickness of the negative. Exposure was one hour under a 500 watt photoflood lamp at a distance of 15 in (about 40 cm).

The pigment The pigment must be water-soluble, unlike that used for bromoil. Suitable pigments include water-colour paints in tubes and powder paints.

The paper Good quality, strong paper is essential for gum bichromate. Any drawing paper can be used, but water-colour paper of 140 lb weight is particularly suitable and has the advantage that it needs no preparation before use. Traditionally, gum bichromate workers always presoaked and sized their paper before using it, because the paper distorted when wet and the pigment was absorbed into the paper. Sizing is still necessary if other kinds of paper are used, and this is most easily done by spraying the paper with household starch in an aerosol can.

Making the emulsion The emulsion can be made under normal room lighting because it does not become light sensitive until nearly dry. First place a little of the pigment on an artist's palette. A ceramic tile or old plate is just as suitable. A quantity of pigment about the size of a pea is sufficient for a 10 × 8 in (25.4 × 20.3 cm) print. Add about 3 ml (about half a teaspoon) of prepared gum arabic and mix thoroughly using a palette knife. Add

about 3 ml of the saturated potassium dichromate solution and continue mixing. The emulsion is now ready for use immediately. It will not keep.

Coating the paper A $2\frac{1}{2}$ in (6 cm) domestic paint brush is the most convenient means of coating the emulsion on to the paper. It may be helpful first to tape the paper down on to a firm support, such as a sheet of cardboard or glass. Use the brush dry and apply the emulsion as evenly as possible, using criss-cross strokes. Do this as quickly as possible and then place the coated paper in a dark place to dry. The paper is ready for use when dry, and it should be used immediately.

The exposure A gum bichromate print is made by contact printing, so the size of the negative dictates the size of the final print. Lith negatives are suitable and so also are paper negatives. The negative is kept in intimate contact with the paper, emulsion-to-emulsion, using a contact printing frame or sheet of glass (see Paper Negatives on page 87). The exposure can be made to sunlight, tungsten photoflood or ultraviolet light. The exact exposure time will have to be worked out by trial and error and will depend on the light source and type of negative. Paper negatives in particular require a long exposure. As a guide, the exposure time using a lith negative and bright sunlight is likely to be somewhere between ten minutes and an hour; a paper negative may well need several hours. As the exposure proceeds, the emulsion darkens visibly and a correctly exposed print shows the image clearly even before development. If a long exposure is necessary, this means that progress can be monitored by carefully lifting a corner of the negative to see if an image is yet visible on the paper.

Developing the print The effect of light on the emulsion is to make it water-insoluble. In areas unexposed to light the emulsion remains soluble and can be removed from the paper by soaking in water. The 'developer' for a gum bichromate print is, therefore, simply water. The development is carried out in subdued light or using a normal darkroom safelight. Wet the print thoroughly with water first and then just allow it to float, face down, on the surface of a bowl of water. Examine the print regularly and you will notice that the pigment gradually dissolves away from the unexposed – highlight – areas. When the print looks right, development is complete. Rinse the print briefly under the tap and hang it up to dry.

Multiple exposures The beauty of the gum bichromate process is that a finished print can be recoated with more emulsion and re-exposed, either using the same negative or a different one. A different colour of pigment can be used in the emulsion and this leads to endless pictorial possibilities.

CREATIVE MOUNTING

If you go to any photographic exhibition the photographs on the walls are very likely to have one feature in common: each one will probably be rectangular in shape and be mounted singly and squarely on a rectangular mount. There are exceptions of course, but the vast majority will fit the above description.

There is as much scope for artistry in the mounting of a photograph as in the taking and processing of it. It is, therefore, sad that all too few photographers think of the presentation of a photograph as a source of creativity in its own right.

Even the simple task of presenting an ordinary, rectangular print on a surround of plain card can be a challenge. Abandon any fixed ideas you may have of what a mounted print looks like and consider the task from first principles. You may be surprised just how many variables there are to consider and how many different combinations are possible. There are, in fact, an infinite number of possible ways of attaching a print to a mount. Some of the decisions that need to be made are:

- What size of mount?
- What colour of mount?
- Mount vertical or horizontal?
- How large a border?
- Surface or window mounted?
- Print centred or offset? Which direction?
- Print level or sloping? Upside-down?

As an aid to creativity, it helps to think of extremes. A tiny print positioned at 45° in the bottom right hand corner of a large pink mount may be just the right way to present your particular photograph.

If a simple, rectangular print can be presented in so many different ways, just think what you can do if you really try hard:

- What shape of print?
- What shape of mount?
- How many prints on a mount? Separate, touching or overlapping?
- How many layers of mounting material? Single, double, multiple?
- Plain or patterned mount? Photographic image on the mount?
- Lines drawn on the mount? Where? What colour?
- Other artwork?
- Titles or captions? Size, position, type face?
- Include something non-photographic on the mount?
- Some form of interplay between print and mount?

The list is endless. All it needs is imagination and a willingness to move away from the traditions which lead us to expect prints to be mounted in a particular way.

The world is not rectangular; neither are human eyes, so why is there such a predominance of unnaturally-shaped pictures? Is it just that cameras have rectangular viewfinders; film comes in rectangular strips and photographic paper is made in rectangular sheets? The rectangle may be the most efficient and economical shape for the manufacture of film and paper, but it is not necessarily the most artistic. One cannot deny the rectangular format is convenient and actually suits most pictures, but this does not mean that all pictures must be rectangular. We all tend to be hidebound and it usually takes positive effort to break away from these traditions.

On the practical side, there are several ways of attaching prints to mounts, some of which are more effective than others. I favour dry mounting tissues – sheets of paper coated on both sides with shellac, which melts when heated. They give a very professional finish when used in a mounting press, but this is a costly piece of equipment. An ordinary domestic iron can be used instead, but this requires some skill; I can personally lay claim to quite a few ruined exhibition prints as a direct result of using an iron. Don't let this put you off; if it is properly mastered, an iron is one of the most useful items of darkroom equipment you can possibly own.

Spray adhesives, such as Scotch Photo Mount, are convenient and quick to use and no special equipment is necessary, but care is needed to prevent the adhesive from falling on the surface of the print. Make sure you use the permanent variety of spray adhesive as there are others intended for temporary work where repositioning of the artwork is important.

Cow gum is another possibility. It is more difficult to apply evenly, but it does have the advantage that, if any should reach the face of the print, it can easily be removed by rubbing it with a finger.

An invaluable piece of equipment for creative mounting is a bevel cutter – a device which holds a sharp cutting blade at a precise angle of 45°. It is used for cutting mat overlays for use as surrounds to framed pictures. Take care in choosing which bevel cutter to buy: some of the best quality cutters, particularly the stainless steel ones, are useless for freehand cutting, because you cannot see what you are doing. I have a clear plastic one which is ideal for the job, because I can see through it to follow the outline I am cutting. This particular bevel cutter also happens to be one of the cheapest. Another suitable model has the blade fixed on the edge of the device where it can be seen during use.

MULTIPLE MOUNTING

There is no reason why two or more prints cannot be presented together on the same mount if it helps to convey the message intended by the photographer. Perhaps there is a story which requires a number of related images to tell it fully. Alternatively, a pair of photographs which contrast with each other might create an element of humour if presented together. Another possibility is to present together several pictures taken in sequence, to produce a time-lapse effect.

A Winning Streak (*overleaf*) Ladies' Day at Royal Ascot is a wonderful occasion for capturing on film the varied facial expressions of the spectators as they follow the horse racing. During one of the races, I shot 47 pictures of the same two people, their expressions changing as the race proceeded. The best 18 pictures, mounted sequentially, give a good indication of the progress of the winning horse. To add more interest, I cut a small silhouette of two neck-and-neck horses out of white paper, and positioned it at the most exciting point of the race, as judged by the expressions. I also added a winning post when the action appeared to be over. The framed piece is 7 in (18 cm) high and 90 in (2.3 m) long in total, and is split into three parts for ease of carrying.

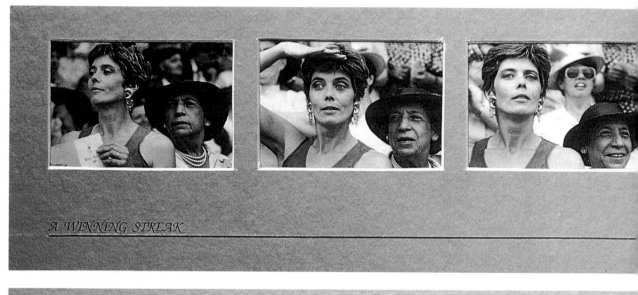

A WINNING STREAK

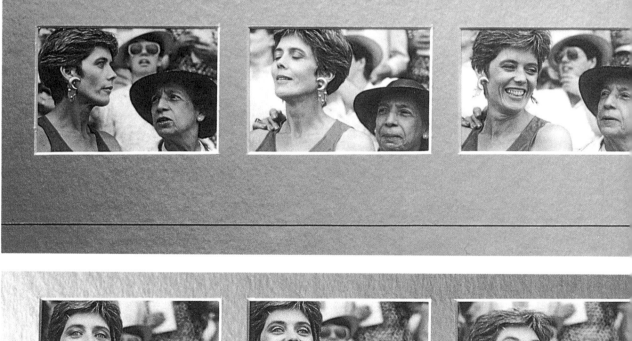

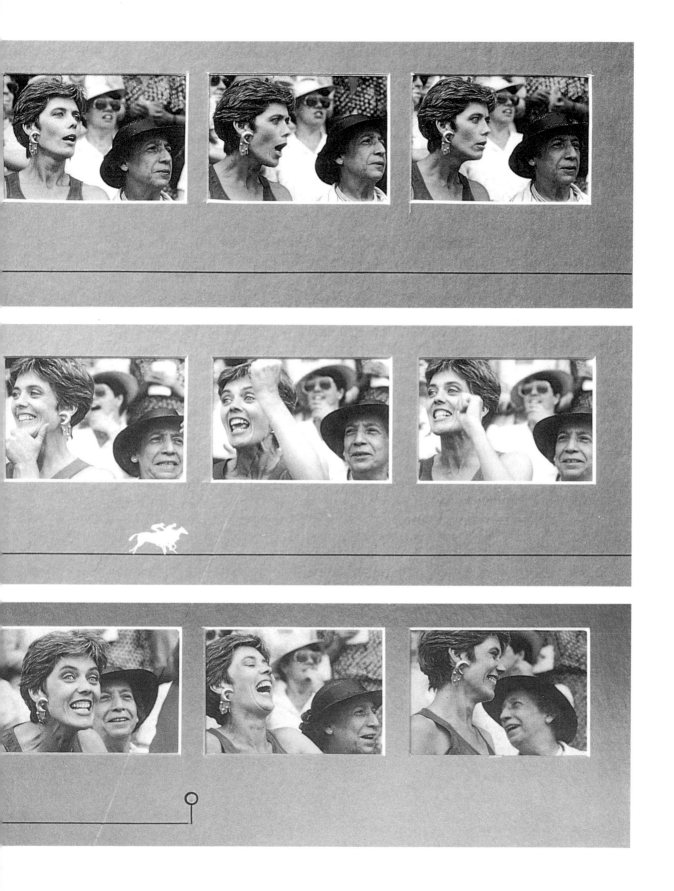

Inter-City

.... with Chris Wainwright ARPS

Inter-City A panel of photographs depicting various facets of rail travel in Britain gives an overall impression when presented together, which cannot be achieved by any of the pictures alone. It also won me a trip to the Miss World Contest.

Spectacles The newspaper is a very important element in this picture, which is why it was also chosen as the theme for the mount. Newspaper yellows rapidly with age, because of the poor quality of the paper, so it was photocopied first.

SYMPATHETIC SURROUNDINGS

Photographers are inclined to present all their exhibition prints on uniform mounts. This form of presentation may be effective if the pictures are to be hung as coherent panels, but it is not necessarily the best way for each individual print. An alternative to this convention is to design each mount specifically to complement and enhance the individual image. Mounting this way does not mean that prints cannot be hung as panels. On the contrary; it is perfectly possible to plan a whole exhibition of uniquely mounted prints.

Selecting a suitable surround for an exhibition print may be a simple matter of choosing

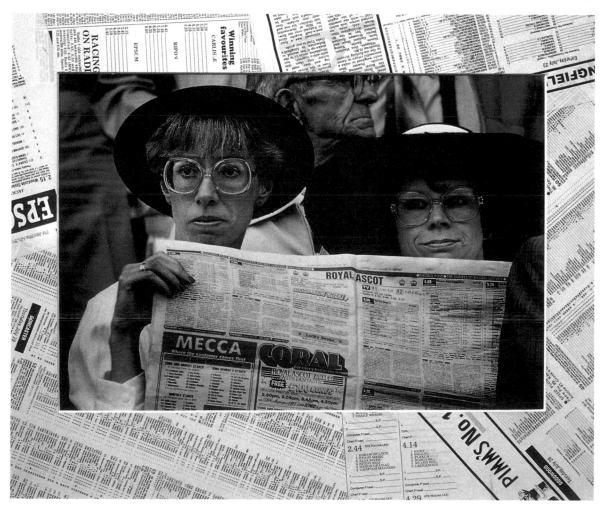

between white, grey, black or coloured mounting board, but the choice does not end there. How about textured or patterned card? Why not printed material? This line of thinking can be pursued to crazy limits if you're not careful. Print presentation does not have to be restricted to conventional mounting materials. Use whatever materials you like and use them in a creative way.

The examples shown on pages 107–112 were specifically made to hang as a panel for an exhibition called 'Do Not Bend'. The show was staged by Arena, a group of 16 photographers working in the south of England. The theme of my panel was racing and each print was mounted sympathetically to the picture.

Various artefacts associated with racing were used as part of the mount, which meant that every picture had to be mounted on two or three thicknesses of mounting card to allow sufficient depth to accommodate the artefact.

In making pictures like these, great care is needed to plan out each stage of the operation.

Faces at the Races This print was quite extensively manipulated by burning and dodging to give emphasis to the faces. A black mount seemed appropriate and, to add a touch of colour to what otherwise would be a rather sombrely mounted picture, I fixed a few betting tickets to the mount.

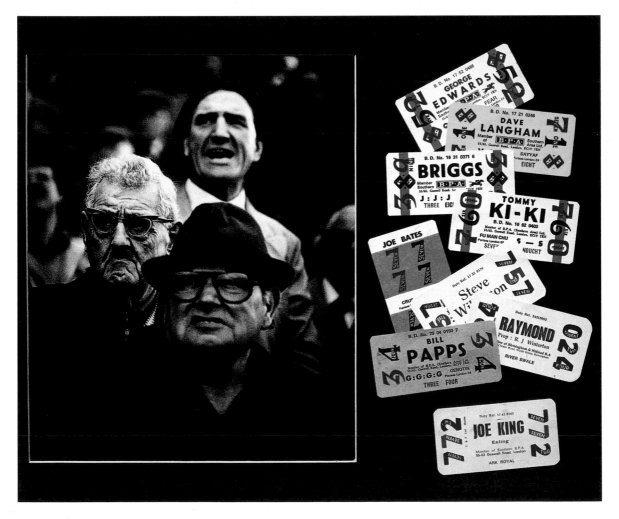

Centre of Attention Ascot railway station is a good location for photographing people as they arrive for the races. It is a fairly colourful scene, so a coloured mount was chosen. The print was mounted at an angle because I felt it suited the spontaneity of the situation, and the final touch was to insert a Royal Ascot race-card into a deep bevelled aperture cut through a double thickness of mount.

The elements of the picture are positioned on different layers and sometimes they can be assembled together only in a specific order. The bevel cutting also needs to be thought through. Sometimes it is done before and sometimes after assembling some of the components; sometimes through one thickness of card and sometimes through two or three.

Dignity (*page 110*) Fine clothes and jewellery are much in evidence on Ladies' Day at Royal Ascot and a red carnation was all that was needed to add to the mood and give a touch of colour. I considered using a real carnation, either dried or pressed, but in the end decided on a hand-made silk flower.

Between Races (*page 111*) Here, a reverse bevel has been used and the print stands proud of the background card. This allowed a Lingfield Park member's badge to be included, which hangs free from the mounted picture. This print is now in the permanent collection of the National Museum of Photography, Film and Television in Bradford, England.

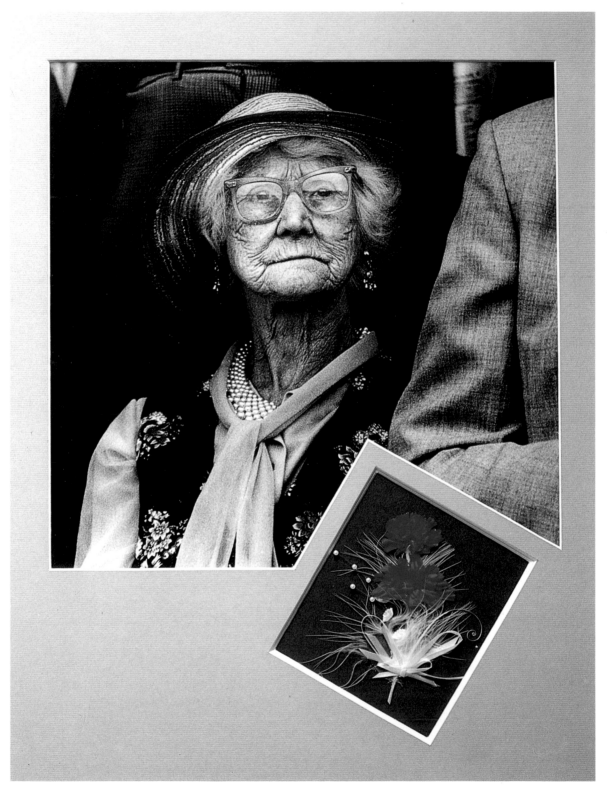

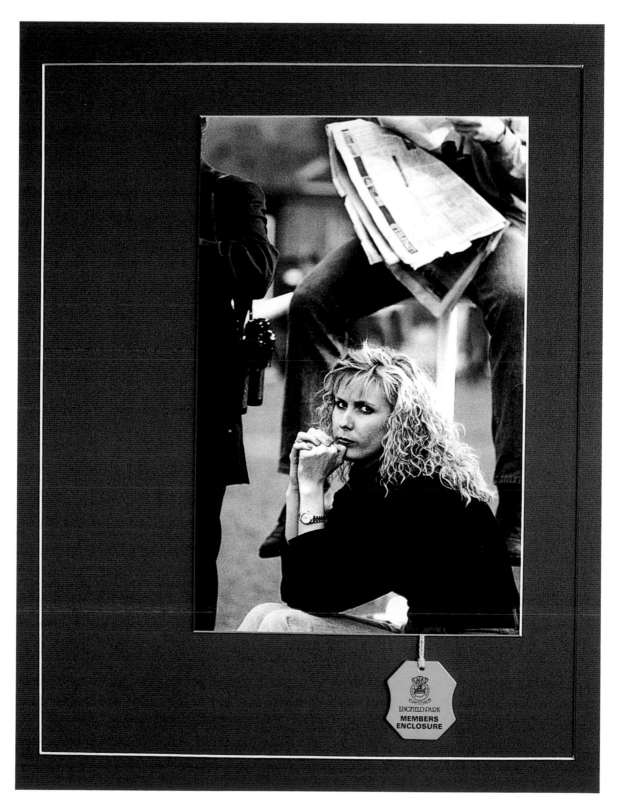

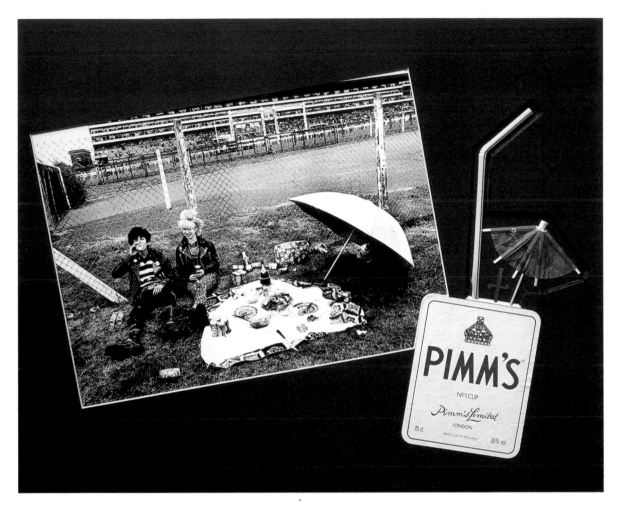

INTERACTIVE MOUNTING

The logical next step from making the mount sympathetic with the picture is to make it actually become part of the picture itself.

The following pictures all involve interactive mounting, where the mat overlay is itself a photograph. In other words, the overlay is cut from a mounted print rather than plain mounting board. The pictures are designed so that there is pictorial interplay between the images on and within the mount. The resulting pictures are, therefore, three-dimensional with the images physically separated on two distinct planes.

Pictures made in this way need to be planned

Punks at Ascot Ascot is an occasion for everyone, not only the nobility and landed gentry. Tickets can cost a fortune and formal dress is mandatory in the main stands. Here, two young people are seen staging what I see as a satirical picnic, with champagne and silver goblets, and they haven't paid a penny: they are outside the perimeter fence! To add to the satire, I have included a few 'cocktail' items in the mount.

Lair of the Cave Monster The idea is that the picture invites you to look closely into the cave. When you do, you see a monster, which is a toy cricket made from plywood. The print of the monster was deliberately printed dark and then dyed with Dylon fabric dye (Mexican Red). Finally, the eye was coloured with a gold felt-tip pen.

and prepared in advance. Sometimes the image is conceived first and the component parts have to be found and photographed. At other times the idea is stimulated by existing photographs. Whichever way it happens, it is useful to keep a small notebook in which to make rough sketches of the ideas as they come to you.

The pictures shown on pages 113–121 were all made in the same way, starting with the two component prints. Some of the prints were partially hand-coloured with fabric dyes or other convenient tinting materials, using Frisk masking film to protect the surrounding area of print (see Chapter Three – Introducing Colours). The two component prints were mounted on separate boards. An aperture was cut in the upper mount, using a bevel cutter freehand, so that it coincided with some aspect of the picture. This upper mount was then overlaid on the lower mounted print, carefully positioning it to give the desired effect and was affixed using double-sided adhesive tape or other appropriate means.

The procedure can best be demonstrated by following, step by step, how a single example exhibition print was made.

Component No. 1 – the fan (*left*) The fan is the picture which will become the overlay. It was first printed full size on a sheet of 20 × 16 in (50.8 × 40.6 cm) paper and was coloured by immersing it in fairly dilute Dylon fabric dye (Bahama Blue) until the depth of colour was satisfactory. It was then pegged up to drip dry. When it was dry, the fan was cut away from its background and dry mounted on a 20 × 16 in sheet of card of as near the same colour to the print as possible. The bevelled aperture was then cut in the card, using a mat cutter. Three sides of the aperture were cut against a straight edge; the fourth was cut freehand, following the scalloped edge of the fan. This completed the upper layer of the composite print.

Component No. 2 – the face (*above*) The second component of the composite picture is the Chinese face. It was printed to the correct size to fit the aperture in the fan picture. The print was mounted on a 20 × 16 in sheet of card, in the correct position to give the required effect when overlaid with the fan. The two mounted prints were then firmly attached using double-sided adhesive tape.

The Fan The finished composite picture, showing interaction between print and mount as well as between monochrome and colour.

Encounter in the Rain This picture took two full days to make, partly because three different dyes were used to colour the umbrella picture, each of which had to dry before the next could be applied. It was also time-consuming because of the complicated outlines which had to be followed in cutting the two bevelled apertures. A suitably multicoloured umbrella was selected, rather than a plain one, even though it was photographed in monochrome. That probably sounds silly, but in hand-colouring a black and white print it is important to make sure that not only the colour is correct, but that the tone is also true to the colour.

The component parts Note that the umbrella was photographed against the light to give a realistic effect of the scene from under it.

When does a 'monochrome' print become a 'colour' print?

Many photographic competitions and exhibitions have separate categories for monochrome and colour work and for a long time hand-coloured prints have been a contentious subject. In which category should they be entered? Colour printers are unhappy if they feel the first prize in their section was awarded to a monochrome-derived print. Equally, monochrome workers are likely to be unhappy if their prize goes to a print which has had colour artificially added to it. You simply can't win either way.

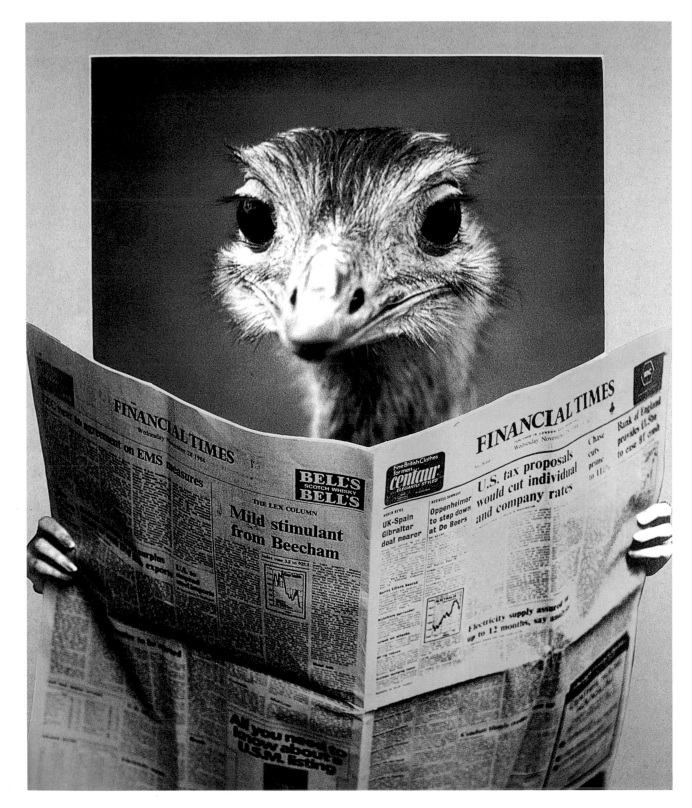

Financial Wizard For this picture, two different dyes were blended to give an authentic colour for the newspaper. The aperture was cut in the overlay by using a straight-edge for three sides and using the bevel cutter freehand, following the contours of the newspaper, for the fourth. My original plan was to use a human subject, but I did not have a suitable negative. I almost didn't bother to use the rhea, because the result was too unlikely, which just goes to show that a logical mind in photography can often inhibit imaginative work.

The point was debated for many years by the Photographic Alliance of Great Britain, which, after much deliberation, made a ruling: the print is 'monochrome' if only a single colour has been added, but it is 'colour' if it includes two or more. At long last, the matter was resolved. I happened to be present at a photographic conference the weekend after the decision was made, and I had a set of interactive prints with me. Several members of the Alliance executive were present as well, and they asked if they could use my pictures to check out the new ruling.

In every case the people concerned were in agreement. Prints like *Financial Wizard* and *The Fan* were judged to be 'monochrome' because only a single colour was used. Prints such as *Encounter in the Rain*, having more than one colour, clearly fitted the 'colour' section. So did *Lair of the Cave Monster*, even though it is predominantly monochrome, simply because the tiny spot of gold added to the eye constituted a second colour!

The component parts

Beanz You should never be surprised at the props which can be found useful in creative photography. Even a humble tin of beans can find its place in a picture, given an initial idea. By the time the beans had been manhandled for long enough to give a uniform layer over a large area, and then photographed under a hot photoflood lamp, they were virtually inedible and the exercise nearly put me off beans for life. The picture was dyed with fabric dye, mounted with a mat overlay made from card of an appropriate 'Heinz' colour and cut to the characteristic shape.

The Camera Club Judge Anyone who is, or has been, a member of a camera club will instantly recognize the significance of this picture. Many club judges are 'croppers', using two pieces of card to show how they would have taken the photograph. On this print I have done the job for them! No hand-colouring is involved because the print is a conventional colour print, made from a colour slide using the Cibachrome process.

Then we came to *Beanz*. The Alliance executive was unanimous in ruling that this print was 'colour' because it contained orange and turquoise. There we are – simple isn't it? Hang on a minute, though – wasn't there an Alliance rule somewhere that said mounts could be of any colour? Oh yes. The turquoise part of *Beanz* is the mount; only one colour – orange – has been added to the print. *Beanz* is therefore a 'monochrome' print!

Isn't it crazy? Do we really have to categorize all our work into convenient slots? Why can't we just make interesting pictures, using our imagination, and have them accepted for what they are? I am sure that rules have a lot to do with the reason why everyone makes rectangular prints!

Practical Applications

This book has described many different ways of producing pictures, but what does one do with them all? They may be hung on the wall at home, or they may be shown in exhibitions. They can be offered for sale, be entered for photographic competitions or they may have pride of place in the family album. Perhaps they are just made for the fun of it. Whatever their final destiny, they were all made for the same purpose: to be looked at. A picture is, after all, just something one looks at, and has no practical application . . . or does it?

This chapter looks at a few practical uses to which photography can be put. Photography may lead to other art forms and it may not always be obvious where one finishes and the other starts. Enjoy yourself discovering new skills and don't worry if you find it's no longer photography. It's still fun.

CHRISTMAS CARDS

Personal Christmas cards are much nicer to receive than bought ones and they're also very satisfying to design and make. The trouble is, once you get into the habit of making your own card every year, your relatives and friends start to expect them. It's then very difficult to go back to buying ordinary ones.

Don't think of making your own Christmas cards as a way of saving money. It's certainly not cheaper. The costs of commercial printing of your artwork are high for the small run you are likely to need.

Making photographic Christmas cards involves very little in terms of equipment that you won't already have in your darkroom. A drawing board is useful, but is by no means essential. Rotring or equivalent drawing pens are useful if you wish your message to be in your own handwriting, or you may choose to use rub-down lettering.

If you choose to use a commercial printer, he will require camera-ready artwork, which means that you must prepare a complete mock-up of the card, both inside and out, including both text and photographs. If you like, you can mark the position of the photograph by means of a box of the correct size and the printer will then electronically 'drop in' the picture supplied to him. To give a good quality reproduction the photograph will need to be scanned, and this should be specified in your instructions to the printer. Scanning increases the cost, but is worth the extra money because of the higher quality of the finished result.

Christmas 1987 Our printers could not manage to retain the subtle details in the high key picture. Instead we bought some good quality textured paper and simply made photocopies. Surprisingly, this simple alternative gave a more pleasing result than our printers were able to achieve at a much higher cost.

Merry Christmas

Snow Games

Off we went to Alpine Slopes,
Skis and sticks and sporting hopes.
Down we slid without a fear.
Snow so white and sky so clear.

The second day we had a thought,
Which rather knocked our winter sport.
We shouldn't miss this welcome chance,
To shoot a snow scene here in France.

When the week was nearly past,
Our Christmas card we had at last.
We didn't learn to ski too well,
But we can wish you *Bon Noel*

Christmas 1988 Here is a card we started thinking about the previous Christmas. The cards on the mantelpiece are ones we had made, in annual sequence, over the previous seven years. The negative was printed through a Paterson rough linen texture screen (see page 40), because a straight print looked too realistic and factual. The interior of the fireplace was cut away, using a scalpel, so that Father Christmas's boots can be seen appearing down the chimney.

Inside The opened card is 'behind the scenes', with Father Christmas pushing a parcel, addressed to the recipient of the card, through the fireplace.

Christmas 1991 – front and rear The idea for this card started with a play on words and yes, this is the correct way round. The 'addition' was drawn on a piece of paper, cut out and stuck on the print to produce the artwork which was given to the printers. The rhyme on the inside reads:

We held our yearly Christmas hunt
For scenes of seasonal cheer
Of doggerel verse and graphic stunt
To set off your new year.

We couldn't find a tastier bird
To pose before the lens.
A robin's dull in monochrome;
We'd used our red felt pens.

'Old Long Neck' made the best design,
Though you might think it queer,
With the rear of the rhea on the front of the card
And the front of the rhea on the rear!

MARQUETRY

An interest in photography can very easily lead to other artistic media. I never had any intention of taking up marquetry; it was just something that happened when exploring the boundaries of photography. It all started by thinking of new things to do with negatives, but ended up as an interest in marquetry in its own right, with no photographic element to it at all.

The early marquetry pictures began with photographic negatives. The negative was placed in the enlarger and projected on to a piece of thin card and the outlines of the major shapes and blocks of tone were traced with a pencil. All or only part of the original scene could be used, and different elements could be introduced from different negatives if required. Freedom of interpretation was possible and, if

desired, part of the picture could be drawn freehand. The card was used as the template for cutting the wood veneers.

Wood veneers from many different species of tree are available and it is surprising how many different colours and shades there are. It is, therefore, important to plan the picture in advance, so that you know exactly which veneer to use in each place. The veneers are all extremely thin and can easily be cut, using a sharp scalpel.

Taking each of the shapes in turn on the template, an aperture is cut in the card with the

The original print (*left*) was unusable because of a fault in the coating of the emulsion, which left a line running the whole length of the film. A tone separation (*right*) is ideal for marquetry because of the simplicity of the shapes and distinctly defined areas of tone.

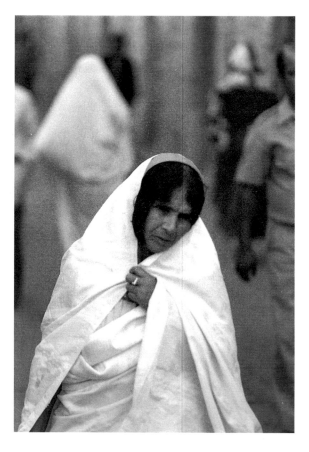

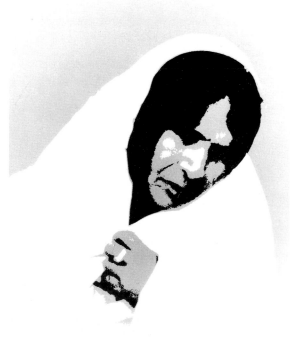

Arab This table mat, measuring $7\frac{1}{2} \times 7\frac{1}{2}$ in, originated from a 35 mm negative taken in Tunisia. There was an intermediate stage, which involved making a tone separation print. This was used as a basis for the marquetry. The background has been improvised.

scalpel and the veneer positioned so that the desired grain pattern can be viewed through it. The veneer is cut to the exact size of the aperture, by cutting it through the aperture in

the card. The cut piece of veneer now exactly fits the hole and is fixed in place by gummed tape on the back. As each shape is cut it is added to the 'jigsaw' and secured in place.

When the marquetry is complete and the entire card has been replaced by veneer, clear self-adhesive tape is applied to the whole of the front of the picture. This holds the pieces in place while the gummed tape is removed by

Chinese There is no photographic element at all in this mat, which shows that ideas developed in photography can be used in other artistic media. The Chinese lettering in the background of the mat literally means 'China'.

dampening it. Finally, the whole picture is mounted on plywood using woodworking adhesive. When this is dry, the tape can be peeled off. A cold dry mounting press is very useful for keeping the marquetry in close contact with the board until the glue dries. All that now remains is to give the finished item 20 coats of varnish, sanding down between coats with 'wet and dry' emery paper and water.

This is a book of photographic techniques so the above description of marquetry has been kept very brief. Specific, detailed books on marquetry techniques exist if you are interested in having a go.

GAMES

If ever you are at a loss for some means of entertaining children, look no further than your darkroom. There you will find considerable potential for making games from your photographs.

Pinning a Tail on a Zebra

If traditionally it was a donkey, rather than a zebra, whose tail children attempted to reconcile with its body, a degree of flexibility in interpreting a well-worn theme can surely be excused. A zebra is better suited to a black and white photograph, anyway. The means of fixing tail to zebra has also undergone a modification from the traditional method, in the example shown here. There is no dangerous pin to threaten young fingers – the game is magnetic.

First, the zebra was printed on a hard grade of paper (Sterling Grade 5) and the area corresponding to its tail was fogged to white light to render it black. To do this, a sheet of glass was placed horizontally in the enlarger light beam, so that a mask could be placed on it. The

The Zebra's Tail

enlarger was set up to give the correct magnification on a sheet of white paper, the same size as the intended print, which was placed on the baseboard. A sheet of card, large enough to obscure the whole image falling on the paper, was then placed on the glass. The out of focus image now falling on the card was used as a template to draw an outline of the zebra's tail on the card. Using a scalpel, the area of the tail was cut out and discarded. This produced the mask.

To make the print, two separate exposures were made on the same sheet of printing paper. The exposure time for each had to be worked out in advance by trial and error. With the negative in the enlarger carrier, but without the mask, the first exposure was made on to photographic paper. Then, without moving the paper, the enlarger's red filter was put in place and the enlarger switched on again. The mask was positioned on the sheet of glass so that the beam of red light passing through the hole in the card coincided exactly with the image of the tail on the paper below. When satisfied that the mask was accurately in position, the enlarger lamp was switched off and the filter swung out of the way. The negative was then removed from the carrier and the second exposure made, this time to white light with the mask in place. The exposed paper was developed as usual. In the resulting print of the zebra, the tail area was black.

The print was masked with Frisk and the area corresponding to the background cut away. The print was then dyed by immersing it in Dylon fabric dye (Golden Glow).

A second print was made, of just the tail area, on a long thin offcut of paper. This print was mounted on card and cut out, following the outline of the tail. The zebra print was also mounted, but this time on very thin card. I used a sheet of 140 lb water-colour paper.

To complete the job, a sheet of magnetic material was fixed to the back of the zebra. The material I used was designed for use on a magnetic wall planner, and consisted of a sheet of plastic impregnated with some form of magnetic substance. Similarly, a short length of self-adhesive steel strip was attached to the back of the tail. This material, bought from a DIY shop, was part of a magnetic fixing system for double glazing.

CLOCKS

The idea of making clocks from photographs started with a chance shot of a man in a crowd holding an old 'Napoleon' clock. What I had not noticed at the time of taking the photograph, but which was evident on making the

Taking his Time A working clock made from a photographic print, using a combination of photographic and woodworking skills.

The rear view The clock motor is shown in place.

Clock Works This clock was made by photographing various bits and pieces rescued from old broken clocks. The camera was set up as for copying prints, on a vertical axis. The clock parts were then arranged within the area covered by the camera viewfinder and photographed. The negative was printed and the print was mounted on hardboard and varnished. A clock motor was then fixed behind a small hole drilled in the mounted picture.

print, was that the hands of the clock were missing. I thought of ways of reintroducing the hands into the photograph, such as drawing them, multiple exposures or montage, but none was satisfactory. It was then I realized that the print was ideal for use as the face of a real working clock, with real hands driven by a small, battery-powered motor mounted on the back of the picture.

Each clock print starts off as a conventional black and white print, say 20 × 16 in in size, and is then dry mounted on hardboard. To protect the surface and give a high gloss finish, the mounted print is varnished, using polyurethane varnish. Ten to twenty coats, each sanded down with 'wet and dry' emery paper and water, give a pleasing surface.

When varnishing is complete, a hole is drilled in the centre of the clock face, large enough to accommodate the spindle of the motor. Clock motors of different sizes, and hands in a variety of styles, can be purchased from woodworkers' suppliers. The motor is fixed to the rear of the mounted picture, inserting the spindle through the drilled hole, and the hands fitted on the spindle. The working clock is now ready to be boxed or framed.

CHAPTER EIGHT

EXPLORING OTHER CREATIVE SOURCES

I hope this book has demonstrated by now that photography should not be taken seriously all the time. Photography offers such a lot of creative potential that it is a pity to think of it as just a recording medium.

Sooner or later, a creative mind, geared to exploring new ideas and experimenting with new techniques, will come up with something which hasn't been done before, or not very often, or not for a long time, or not seriously. Rather than being the point at which the process stops, this is where real creativity begins. Someone has to be first and there is no reason why it should not be you.

Try to think of new ideas, not only in terms of picture content, but also in terms of new techniques. Think of photography broadly; there's more to it than you might think and it isn't always intended for pictorial purposes. If you do think of an idea, however odd it may seem, don't dismiss it. The only way to find out if it works is to try it out.

This chapter should be viewed in a light-hearted way. The techniques explored offer photographic potential and a lot of enjoyment. It should not be assumed that they will all produce masterpieces but, in the right hands, they just might. Use them to stimulate ideas and come up with your own personal ways of producing pictures. Experiment, have fun and see what happens.

PHOTOCOPIER ART

One of the simplest ways ever devised of making a photograph is also one of the most commonplace, yet it is probably dismissed by most 'serious' photographers as not being a source of pictorial images, if indeed it was ever considered at all. That the humble photocopier can so readily be taken for granted shows just how much a part of all our lives it has become.

Certainly the quickest way I know of creating a self portrait is to put one's head on a photocopier. The only word of warning is this: shut your eyes! Those lights really are intense.

Since most photocopiers are used communally, it is probably worth making sure no one is around when you carry out your creative xerography; your less artistic colleagues may not fully understand the reasons for your strange exploits. Also, unless you are happy to risk being fired, it might be an idea to restrict your self portraits to faces and hands!

Backlit Photocopies
A photocopier can also be used as a means of copying prints. These days photocopiers are capable of producing good quality images, even from photographs. A copy made in this way is distinctive: contrast is very much enhanced; grey tones are partially eliminated and the image is 'flattened', with a sharp edge

Xerography A self portrait, made on a photocopier. The expression is an understandable response to the blinding light.

to areas of tone. A photocopy has some similar-ities to a lith image (see Chapter Four – Lith Film), but without the dense black obtainable with lith film. By and large, photocopied prints are very much second rate to an original print and would not normally be considered as a serious means of reproducing a photograph for the exhibition wall.

There is, however, an interesting creative spin-off from photocopied prints. Photocopier paper is much thinner than photographic paper

and is, therefore, more translucent. Also, it is not manufactured to such a high quality as photographic paper and the texture of the fibres is more pronounced. This means that some interesting effects are produced if a photocopy is illuminated from behind. Both the image and the texture of the paper are evident. The backlit copy can now be rephoto-graphed in the camera to produce a conven-tional negative which contains the texture as well as the image.

This technique could be taken a step further by photocopying the print on various types of paper to explore different textures. Art shops have a plentiful supply of suitable materials.

The original print (*above*) shows a 'grab' shot, taken in torrential rain, which is generally dull when printed normally. It also suffers from camera shake. As an experiment, an enlarged portion of the print was photocopied (*left*). The result has the typical appearance of a photocopy, and would not have been taken any further had it not inadvertently been viewed against a bright light.

Rained Off (*opposite*) The photocopy was taped to a window on a sunny day and rephotographed on FP4 from inside the house. The negative was then printed on Agfa Brovira Grade 5 paper. The mottling in the light, background areas of the finished print, is the image formed by the texture of the fibres in the photocopier paper, revealed by rephotographing it against the light.

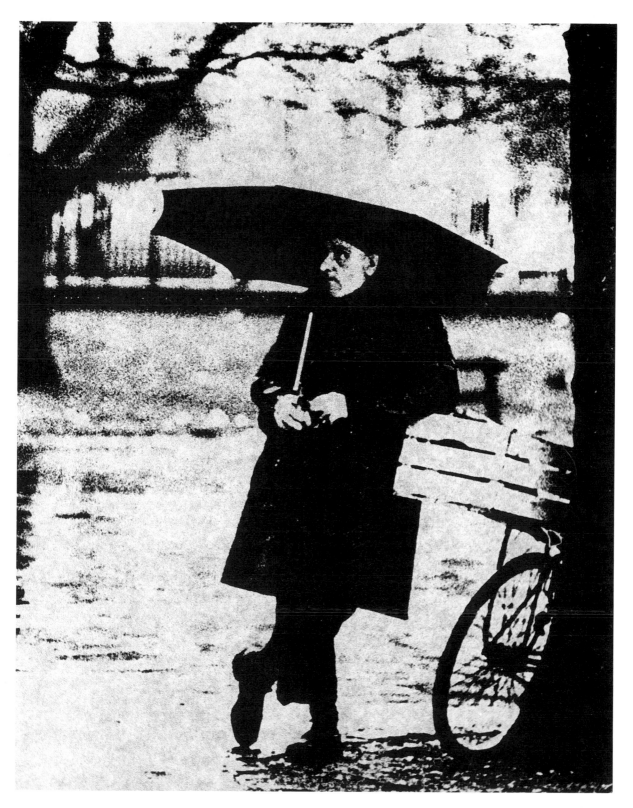

PINHOLE CAMERAS

Pinhole cameras are certainly not new, but that is all the more reason for resurrecting the technique and adapting it for use in modern picture making.

A pinhole camera is a box, blackened on the inside, with a pinhole – literally – at one end and a sheet of photographic material attached to the inside of the box at the opposite end. The pinhole acts as a lens and is able to focus an image on a sheet of sensitive material, which can be either film or paper.

A pinhole camera is easily made from any old box, provided the box is lightproof. The distance between the pinhole and the film determines the focal length of the 'lens', so large boxes produce telephoto images and small ones wide-angle images. The pinhole itself must have a sharp edge if the image is to have any quality at all. A hole made in a sheet of thick cardboard is likely to be ragged and this produces an image of poor definition. It is, therefore, a good idea to inset a piece of aluminium foil into the end of the box, which, being much thinner, will allow a cleaner pinhole to be made, and hence produce a much higher quality image.

To make an exposure, a sheet of film or paper is inserted in the camera in the darkroom and the lid securely replaced. The camera is then transported to the place where it is to be used, with the pinhole covered by some means. The easiest way is to place a finger over the hole. The camera is positioned as accurately as possible, bearing in mind it has no viewfinder, and the exposure made by removing the finger. A long exposure will be needed because of the tiny aperture of the 'lens', particularly if paper rather than film, is used. At the end of the exposure, the pinhole is covered, the camera is returned to the darkroom, and the film or paper is developed.

As the camera has no means of advancing the film, only a single image can be made at a time.

Also, without a meter, the exposure time is a matter of trial and error. All in all, using a pinhole camera can be a tedious business because one has to keep going back to the darkroom. However, you can speed up the process by using a large, lightproof changing bag and a lightproof film or paper store. This lets you change the film or paper on location.

An alternative way of producing a pinhole photograph, which is perhaps cheating just a little (but who cares?) is to use a single-lens reflex camera. With the lens removed, a sheet of aluminium foil is fixed over the lens mount of the camera, and a pinhole made in the centre of the foil. The whole object of using a pinhole is perhaps defeated if a lens is available, but the advantage of an SLR is that through-the-lens metering can be used. This enables the aperture of the pinhole to be calculated, which makes it possible to determine accurately the exposure for all future pictures.

There are four variables which affect the density of a photographic image – light intensity, film speed, exposure time and aperture. If two of these parameters – light intensity and film speed – are kept constant, it follows that the other two – exposure time and aperture – must have a reciprocal relationship to each other. If two correctly and identically exposed negatives are now made by trial and error, one through a lens and the other through a pinhole, the pinhole picture needs very much the longer exposure, because its aperture is much smaller. Let's say the exposure for the lens picture was 1/30 second at f5.6, but the pinhole picture required a 15 minute exposure to produce the same density of image. The pinhole aperture can then be worked out by successively doubling the time and halving the aperture, starting from 1/30 second at f5.6, until the time reaches 15 minutes, along the following lines:

Time	1/30	1/15	1/8	1/4	1/2	1s	2s	4s
f	5.6	8	11	16	22	32	45	64
Time	8s	15s	30s	1m	2m	4m	8m	15m
f	90	128	180	256	360	512	720	1024

Candles A picture of a single candle, taken on a Canon AE1 with three pinholes in place of a lens.

image. It is, therefore, an easy matter to use several 'lenses', simply by sticking the pin repeatedly through the aluminium foil. The arrangement of pinholes determines the composition of the multiple image and the degree of overlap.

PRINTED CIRCUIT BOARD

Electronics experts will certainly be familiar with printed circuit board (PCB) but photographers may not be. Although the process by which printed circuits are made is essentially a photographic one, it is doubtful whether the pictorial applications of the process have often been considered.

PCB is a rigid sheet of fibreglass clad in a coating of metallic copper. The surface of the

An experiment with printed circuit board Four 35 mm lith negatives were exposed on a sheet of PCB, using exactly the same technique as that used for constructing electronic circuits.

The aperture of this particular pinhole was therefore f1024! (Whilst this very rough and ready calculation serves our purposes perfectly well here, strictly speaking it should take into account reciprocity failure, which means that very long exposure times give proportionally lower responses than shorter exposures.)

With a pinhole camera, light passes straight on to the film or paper and images are not formed by refraction. As a result, everything in front of the 'lens' is sharp, irrespective of whether it is a few centimetres in front of the camera, or in the far distance.

The creative possibilities of the pinhole camera are far greater than you may realize. In the same way that one 'lens' produces one image, two 'lenses' produce two images, and so on. Each 'lens' produces a complete, individual

copper is protected by a photoresist, which is sensitive to ultraviolet light.

The intended purpose of PCB is in making electronic circuits, and it is a means of assembling electronic components in a relatively small space without the need of loose wires. The principle is that the copper coating is selectively etched away, to leave thin tracks of copper which conduct current between the points at which the components are to be soldered.

An electronic circuit is transferred to PCB via a circuit diagram made on lith film. It doesn't take much imagination, therefore, to realize that any image on lith film can be transferred to PCB by means of the same process.

The positive lith image – whether a circuit diagram or a picture – is exposed on PCB by contact printing, using an ultraviolet light source. This selectively affects the photoresist so that it no longer protects the copper in the exposed areas. The board is finally 'developed' in an etching bath of ferric chloride solution, which differentially removes the copper coating in the areas exposed to ultraviolet light.

CRYSTALS IN THE DEVELOPER

Not every useful technique can be found described in books on creative photography, and there will always be new ones to discover, either by experimentation or by sheer bad luck. The 'technique' described below was quite unintentional, and for all but one of the negatives on the film was an utter disaster.

The contact sheet The extent of the damage caused by crystals in the developer is evident in the contact sheet of the film.

Star Singer A singer among the bright lights of a stage? Not at all – the light spots are where crystals in the developer accidentally stuck to the film!

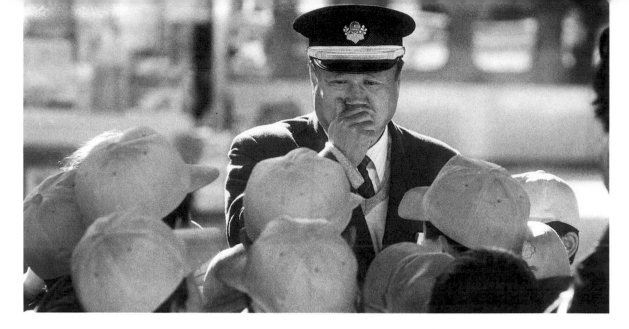

I would not recommend trying to recreate this effect; instead, use my experience as encouragement to turn your own misfortunes to advantage. In other words, if something goes wrong, make the best of it you can.

It started, as mistakes often do, by trying to rush. I had a film to develop but had run out of developer, except for a few brown dregs in the bottom of an old bottle. Rather than taking the safe option of waiting until I could obtain more, I decided to risk the old stuff. It was a bad choice, because I had not noticed that the developer had partially crystallized.

During development, the crystals adhered to the surface of the film, resulting in black splodges caused by localized overdevelopment. When the negative was printed, the spots became bright highlights.

MIRROR IMAGES

Mirrors have always been a source of fascinating imagery. For generations, the Hall of Mirrors has kept both children and parents amused at fairgrounds. In much the same way, interesting photographs can be produced by mirrors – for example by placing a vertical mirror on a print and rephotographing the symmetrical image this creates.

The original print shows quite clearly, not a sergeant major, but a railway guard in Japan. The sergeant major's mouth in the mirror picture is, in fact, the guard's left eye reflected in a mirror.

Sergeant Major People tend to think of a sergeant major as a domineering ogre, the peak of his cap pulled down over his eyes, bellowing instructions.

When used on photographs of people, this technique creates distorted, cartoon-like faces. At its simplest, when the mirror is placed centrally to the face so that it divides it equally, the result is a symmetrical face composed of either the left or the right hand side and its reflection. It is surprising just how different the two faces can be; no one is perfect, but some people are less perfect than others.

For more extreme results, try moving the mirror sideways so that the face is widened or narrowed. Notice how the personality of the subject changes. Now rotate the mirror so that it is no longer perpendicular to the face. All sorts of caricatures now appear: people with wide heads and narrow chins; others with pointed heads and eyes close together. Each one has a personality of its own and it is fascinating to watch as a pathetic character changes into a tough guy, just by moving a mirror.

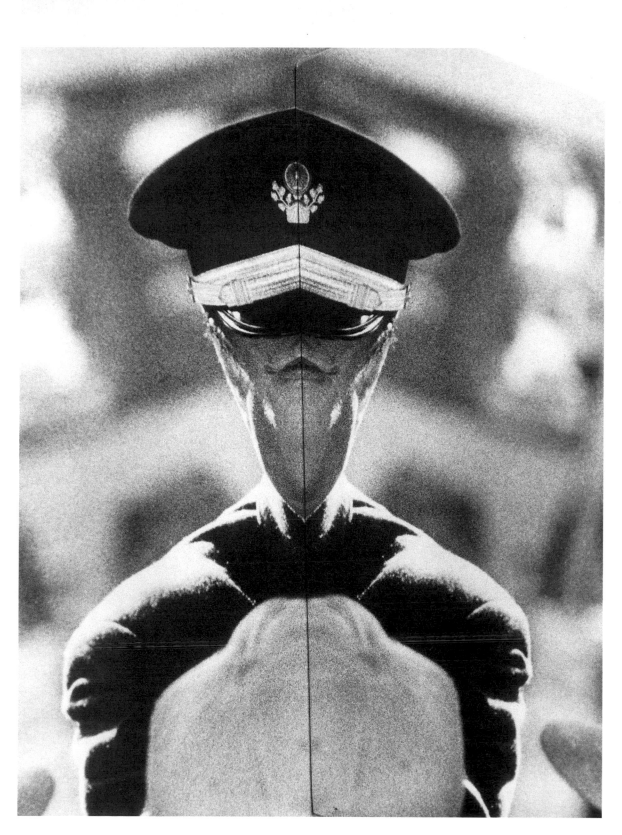

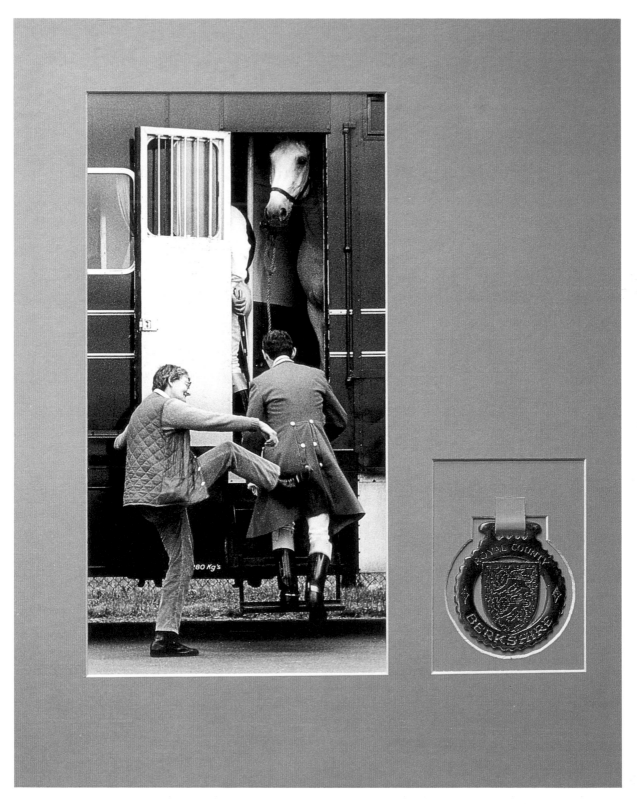

POSTSCRIPT

Many techniques have been described in this book for making creative photographs. They just happen to be the ones I have found useful for my own ideas. Many, many more techniques are possible, and a study of the numerous textbooks on photography will provide plenty of scope for further creativity. There is no doubt that new techniques will be discovered in the future by photographers seeking something different, and there is no reason at all why that photographer should not be you.

This book began by looking at pictures which were purely photographic and straight. Little by little, ideas for adding creatively to photographs have been explored. I hope to have been able to show that non-photographic elements, far from being 'cheating', can often be used to good effect. Indeed, the very boundaries of photography have been examined, and sometimes this led out of photography completely, and into other artistic media. Rather than diminishing the value of the photograph, this exciting visual exploration, in my view, reinforces the value of creative imagery.

Imaginative picture-makers do not feel hidebound to follow non-existent rules which say that all photographs must be straight and that adding something by hand is forbidden. Just because most exhibitions feature rectangular prints hanging on rectangular mounts in neat rows, it does not mean you cannot be different. If you feel the exhibition rules are too restrictive, you can always choose not to enter the exhibition, but whatever you do, don't stop the creative work.

Remember – there's more to life than Photography.

Striking the Postillion 'My postillion has been struck by lightning' was the phrase which immediately sprang to mind when I shot this picture, quite spontaneously, of one of the Queen's coachmen being caught unawares in the process of derigging the open landau. A horse brass with the Royal Berkshire coat of arms, inset in a coloured mount, completes the picture.

TECHNICAL DETAILS

Title	Camera	Lens	Film	ISO	Developer	Technique
Andy Capp	Miranda Sensorex EE	50 mm	Pan-F	50	Microphen	Tone line
Angel from Hell	Miranda Sensorex EE	50 mm	FP4	100	Acutol	Hard paper grade
The Apron Pocket	Miranda Sensorex EE	50 mm	Kodachrome	64	Trade	*In situ* montage
Arab	Canon AE1	50 mm	FP4	100	Acutol	Marquetry
Beanz	Canon AE1	50 mm	FP4	320	Acutol	Tinting/Mounting
Best Foot Forward	Canon T70	135 mm	FP4	400	Acutol	Gum bichromate
Between Races	Canon AE1	135 mm	FP4	400	Acutol	Mounting
Bonfire Night	Canon AE1	Various	FP4	400	Acutol	Sandwich
Burial on the Mount of Olives	Canon AE1	300 mm	FP4	400	Acutol	Bromoil
By the Mere	Canon AE1	135 mm	FP4	400	Acutol	Push processing
Camels	Canon AE1	300 mm	FP4	400	Acutol	Texture screen
The Camera Club Judge	{ Canon AE1 / Miranda Sensorex EE	135 mm / 50 mm	FP4 / Kodachrome	400 / 64	Acutol / Trade }	Mounting
Candles	Canon AE1	Pinhole	FP4	400	Acutol	Pinhole camera
Carolus Rex	Miranda Sensorex EE	50 mm	FP4	200	Acutol	Superimposition
Centre of Attention	Canon AE1	300 mm	FP4	400	Acutol	Mounting
Check Mate	Canon AE1	135 mm	FP4	400	Acutol	Toning/Mounting
Chinaman in a Mask	Canon AE1	135 mm	FP4	400	Acutol	Photomontage
Clock Works	Bronica ETRC	75 mm	FP4	125	Acutol	Clock
Colour Construction	Canon AE1	135 mm	FP4	400	Acutol	Etch bleach
Conspirators	Canon AE1	135 mm	FP4	400	Acutol	Burning & dodging
Crystal Gazer	Miranda Sensorex EE	50 mm	Kodachrome	64	Trade	Gum bichromate
Daphne	Canon AE1	135 mm	FP4	400	Acutol	Push processing
Dawn Flight	Canon AE1	135 mm	FP4	400	Acutol	Print copying
Demons	Canon AE1	50 mm	FP4	400	Acutol	Photomontage
Dignity	Canon AE1	135 mm	FP4	320	Acutol	Mounting
Dungarees	Canon AE1	135 mm	FP4	400	Acutol	Toning/Mounting
Enchanted	Miranda Sensorex EE	50 mm	Peruchrome	64	Trade	Lith/Slide sandwich
Encounter in the Rain	Canon AE1	50/135 mm	FP4	320/400	Acutol	Tinting/Mounting
F.U.s	Canon AE1	135 mm	FP4	400	Acutol	Toning/Mounting
Faces at the Races	Canon AE1	135 mm	FP4	400	Acutol	Mounting
The Fan	Canon AE1	50/135 mm	FP4	320	Acutol	Tinting/Mounting
Financial Wizard	Canon AE1	50/300 mm	FP4	320	Acutol	Tinting/Mounting
Flower	Miranda Sensorex EE	50 mm	Kodachrome	64	Trade	Texture screen
Fox Fur – and Rita	Miranda Sensorex EE	50 mm	HP3	400	Acutol	Toning
Ghost Town	Miranda Sensorex EE	50 mm	Tri-X	600	Acutol	High contrast developer
Hallucination	{ Miranda Sensorex EE / Miranda Sensorex EE	50 mm / 50 mm	HP3 / Kodachrome	400 / 64	Acutol / Trade }	Slide sandwich

Title	Camera	Lens	Film	ISO	Developer	Technique
Holiday Slide	Canon AE1	50 mm	FP4	320	Acutol	Tinting/Mounting
	Canon T70	135 mm	FP4	400	Acutol	
Homeless	Canon AE1	50 mm	Kodachrome	64	Trade	Lith mask
Inter-City	Miranda Sensorex EE	50 mm	HP3	1600	Acutol	Mounting
The Kiss	Canon AE1	135 mm	FP4	400	Acutol	Texture screen
Lair of the Cave Monster	Canon AE1	50 mm	FP4	320/400	Acutol	Tinting/Mounting
Lakeside	Canon AE1	135 mm	FP4	400	Acutol	Print copying
Mirror Image	Canon AE1	135 mm	FP4	400	Acutol	Lith
Pollution	Miranda Sensorex EE	50 mm	Plus-X	125	Aculux	Toning
Positive and Negative	Miranda Sensorex EE	50 mm	Pan-F	50	Acutol	Lith/Mounting
Punks at Ascot	Canon AE1	28 mm	FP4	320	Acutol	Mounting
Racing Colours	Canon AE1	135 mm	FP4	320	Acutol	Tinting
Rained Off	Canon AE1	135 mm	FP4	400	Acutol	Backlit photocopy
Remembrance	Miranda Sensorex EE	50 mm	Pan-F	50	Acutol	Paper negative/ Toning/Tinting
Rooftops	Canon T70	135 mm	Fuji Neopan	1600	D-76	Solarization
Royal Holloway College	Bronica ETRC	75 mm	FP4	100	Acutol	Multiple exposure
Salute	Canon AE1	135 mm	FP4	400	Acutol	Paper negative
Self Portrait	Miranda Sensorex EE	50 mm	HP3	650	Acutol	Lith/Photomontage
Self Portrait with Graffiti	Canon AE1	135 mm	FP4	400	Acutol	Tinting/Mounting
Sergeant Major	Canon AE1	135 mm	FP4	400	Acutol	Mirror image
The Sleeping Partner	Canon AE1	135 mm	FP4	100	Acutol	Photomontage
South Door	Miranda Sensorex EE	50 mm	Kodachrome	64	Trade	Lith mask
Spectacles	Canon AE1	135 mm	FP4	400	Acutol	Mounting
Splash!	Miranda Sensorex EE	50 mm	HP3	1600	Acutol	Lith/Tone separation
Star Singer	Miranda Sensorex EE	50 mm	FP4	750	D-76	Crystals in the developer
Steep Holm from Sully Island	Canon AE1	135 mm	FP4	400	Acutol	Hard paper grade
Stone Gables	Canon T70	50 mm	Fuji Neopan	1600	D-76	Bas-relief
Striking the Postillion	Canon AE1	135 mm	FP4	320	Acutol	Mounting
Taking his Time	Canon AE1	135 mm	FP4	400	Acutol	Clock
A Threepenny Opera	Miranda Sensorex EE	50 mm	FP4	200	Acutol	Burning & dodging
Tying Up	Canon AE1	135 mm	FP4	100	Acutol	Bromoil
Welcoming Party	Canon AE1	135 mm	FP4	400	Acutol	Texture screen
Winners and Losers	Canon AE1	Various	FP4	Various	Acutol	Photomontage/ Mounting
A Winning Streak	Canon AE1	135 mm	FP4	400	Acutol	Mounting
Xerography	Xerox photocopier					Photocopier
The Young and the Old	Miranda Sensorex EE	50 mm	HP3	1600	Acutol	Push processing/ Hard paper grade
The Zebra's Tail	Canon AE1	135 mm	FP4	320	Trade	Game

CHECKLIST OF EQUIPMENT AND MATERIALS

A glossary of items which every creative photographer should have in his or her darkroom, and their uses.

Acacia Natural gum obtained from species of *Acacia*, used in the gum bichromate process. Also known as gum arabic.

Acetone Organic solvent for removing nail varnish from a print after use as a mask for toning or tinting.

Acutol High acutance developer for films, made by Paterson. Although primarily intended for use with films up to ISO 200, it is useful for uprating.

Adhesive tape Universally useful. Tiny strips can be used to keep negatives or slides in position when sandwiching or contact printing. Also used in marquetry.

Airbrush A device for applying paints, inks or dyes by spray action. Very controllable and useful for retouching or hand-colouring prints.

Aluminium foil The best material in which to make a pinhole for pinhole photography.

Ammonium dichromate A photographic bleach, used particularly in gum bichromate.

Bellows For close-up work, particularly copying transparencies on a single-lens reflex camera.

Bevel cutter A device with a 45° blade designed for cutting mat overlays from card.

Bleach Photographic bleaches are usually based on potassium ferricyanide or a copper salt.

Blotting paper Used for blotting surface water from a bromoil matrix prior to inking, or from an etch bleached print prior to colouring.

Blue toner Usually an iron toner, based on a ferric or ferric ammonium salt.

Bromoil brushes Specially made brushes for bromoil. The bristles are cut to a slope to facilitate the correct strokes.

Bromoil pigments Specially made pigments for bromoil, no longer available but can be substituted by printers' ink or oil paints.

Brovira Fibre-based or resin-coated paper made by Agfa. Famous for its unique Grade 6 paper, at one time the hardest on the market, though this grade is sadly no longer available.

Brush Brushes of various types are useful in creative photography: spotting brushes for retouching prints or applying photographic opaque to negatives; brushes for hand-colouring prints; $2\frac{1}{2}$ in (6 cm) paint brush for coating paper for gum bichromate; special bromoil brushes.

Car touch-up spray Aerosol paint for car bodywork . . . and prints. Useful for applying opaque colours to a print, and also for 'blocking out' in sheet negatives.

Card Card of various sizes and thicknesses has a multitude of uses: mounting prints; burning and dodging; marquetry templates.

Cardboard box The starting point in making a pinhole camera.

Charcoal Ideal for retouching paper negatives.

Chinese hair pen A brush used in Chinese calligraphy which has an extremely fine tip. It is therefore ideal for spotting prints.

Chloroform Solvent for removing nail varnish from a print after use as a mask for toning or tinting.

Chromogenic film Black and white film, such as Ilford XP2, which gives exceptionally sharp results and is developed using colour processing chemistry.

Cibachrome Colour reversal paper which can produce some interesting effects when used with black and white negatives. Has been replaced by Ilfochrome Classic.

Citric acid An ingredient of the bleach used in the etch bleach process.

Clock parts A motor, battery and pair of hands are needed to make a clock from a photograph.

Close-up lenses Supplementary lenses for close-up work, particularly copying prints.

Cocktail sticks Their sharp ends are a convenient way to apply a tiny spot of photographic opaque or typewriter correction fluid when retouching a negative or print.

Colour printing paper Can be used for creative printing of black and white negatives.

Coloured paper Can be mounted on to card to widen the range of mounting card colours available for mounting prints.

Coloured pencils Useful for hand-colouring.

Contact printing frame A device for holding a negative in intimate contact with the paper during contact printing. Frames can be any size from 35 mm to 20 × 16 in (50.8 × 40.6 cm) or larger.

Copper sulphate A photographic bleaching agent used, for example, in the bleaches for bromoil and etch bleach.

Copying camera For many creative techniques prints, slides or artwork must be copied. The larger the format the better, although a 35 mm single-lens reflex camera is perfectly adequate. A close-up accessory may be necessary and a tripod should be used.

Copying film Specific films are available for copying work. These are designed to give average contrast and fine grain, which may or may not be appropriate for creative effects.

Cotton buds Used to apply dyes or bleach selectively to small areas of a print.

Cotton wool A useful means of applying dyes or toners over small areas. Particularly useful in the etch bleach process to scrub away softened emulsion.

Cow gum A means of masking a print to define areas for toning or tinting.

Craft knife Used with a steel ruler for trimming mounted prints.

Delta Ilford Delta is a very fine grain black and white film based on flat grain technology.

Dilute developer Print developer, diluted about 1 + 30 is used for tone separation.

Dodgers Shapes on sticks, used to control light from the enlarger beam and hence the tones in a printed image. Easily made from card and wire.

Dot screen *see* Texture screens.

Double-sided tape For double-mounting of prints, where two thicknesses of card are to be attached.

Drawing board A luxury perhaps, but there is nothing better for squaring up and marking mounting card and artwork.

Drawing inks Coloured drawing inks are suitable for hand-colouring photographs, including etch bleach.

Dry mounting press Heavy duty, heated press which is the best way of mounting a print on card. Used with dry mounting tissues. Can also be used as a cold press for gluing and mounting marquetry.

Dry mounting tissues Thin sheets of tissue which melt on application of heat. Used in a dry mounting press for mounting prints on card.

Dyes One of the most versatile methods of hand-colouring a black and white photograph. Fabric dyes and food dyes are both suitable.

Dylon Manufacturers of fabric dyes available in a wide range of colours, which are suitable for hand-colouring black and white photographs.

Emery paper Used wet for sanding down varnish between each coat.

Enlarger carrier Must be a glass carrier for printing through negative sandwiches or when using texture screens.

Etch bleach Bleach which selectively strips the emulsion from resin-coated paper in shadow areas only.

Exposure meter Use with a grey card for copying prints.

Extension tubes For close-up work, particularly copying transparencies on a single-lens reflex camera.

Fabric dyes Very convenient colours for tinting a black and white photograph.

Felt-tip pens Useful for hand-colouring.

Ferri Popular name for potassium ferricyanide, a useful bleach used with a brush for brightening highlights in a print. Used with hypo to avoid staining.

Ferric chloride Basis of the etching solution used for printed circuit board.

Filters A set of colour filters is useful for changing the image colour when printing black and white negatives on colour paper. Soft focus filters can be placed in the enlarger beam to give a soft focus effect.

Fixer Hardening fixer is usually used in photography, but plain hypo is necessary for bromoil.

Focusing screen In large and medium format cameras, and 35 mm cameras with a removable pentaprism, the screen can be used to trace the component images of a multiple exposure, to aid registration.

Food dyes Very convenient colours for tinting a black and white photograph.

FP4 A black and white film manufactured by Ilford. Nominally rated at ISO 125, but can be uprated.

Frisk Manufacturer of airbrush requisites. The name is synonymous with masking film, which is useful for masking prints prior to selective tinting or toning.

Glass A large sheet of glass is useful when contact printing to keep paper negatives or large sheets of lith film in intimate contact. Also for positioning diffusion media in the enlarger beam. A smaller sheet of glass is used as a palette for bromoil inking.

Gold pen Useful for lettering on a print mount.

Greaseproof paper Can be used as a texture or diffusion screen.

Grey card Card of an accurate tone of grey designed for calibration of exposure meters. Useful for calculating exposure when copying prints.

Guillotine The best means of cutting a print perfectly straight, but of limited value with a print mounted on thick card.

Gum arabic Natural gum obtained from species of *Acacia*, used in the gum bichromate process.

Gummed tape For fixing pieces of veneer to the template during marquetry.

Hardboard Rigid backing material for mounting prints, particularly when making clocks or games from them.

Hog hair brush A bromoil brush used for the initial application of pigment.

Hydrogen peroxide An ingredient of the bleach used in the etch bleach process.

Hypo Common name for sodium thiosulphate, the chief photographic fixing agent. Used plain for bromoil.

Ilfobrom Fibre-based paper made by Ilford. The Grade 5 paper is a particularly hard grade.

Ilfochrome Classic Replacement for Cibachrome colour reversal paper. Can produce some interesting effects when used with black and white negatives.

Illumitran A slide copying instrument manufactured by Bowens.

Inks Coloured drawing inks are suitable for hand-colouring photographs, including etch bleach.

Iron A domestic iron is a cheaper means of dry mounting prints than a dry mounting press. Do not use a steam iron unless the steam supply is switched off.

Iron toner A toner based on a ferric or ferric ammonium salt which gives a blue colour due to conversion of the silver image to ferric ferrocyanide or Prussian blue.

Kentint Range of Kentmere pre-coloured resin-coated paper.

Kentmere Art The only photographic paper on the market that can be used for bromoil. Available under the Luminos label in the USA.

Lens cleaning tissue Useful as a texture screen in creative transparency-making.

Letraset Rub-down lettering that is useful for lettering on a print mount, or as part of artwork.

Lightproof box For storing exposed sheets of paper whenever it is necessary to make sequential exposures. Can also be used for drying wet-coated papers, for example for gum bichromate.

Lights Good illumination is important for copying prints. Tungsten photofloods are ideal for copying on black and white film, but you need to conduct exposure compensation tests for individual films, because the nominal speed of black

and white film is reduced under tungsten lighting. For copying colour prints, daylight bulbs are available or a blue filter can be used.

Linseed oil Diluent for bromoil pigments.

Lipstick Even lipstick has found a place in hand-colouring.

Lith developer Extreme contrast developer based on hydroquinone, specially formulated for processing lith film. It can also be used with conventional bromide papers to increase contrast.

Lith film An orthochromatic, extreme contrast film which reproduces images in black and white without intermediate grey tones. It is developed in lith developer under a red safelight. It is available in sheet form or as 35 mm film.

Macro lens For close-up work. Particularly useful for copying transparencies on a single-lens reflex camera.

Magnetic sheet Just one of the unlikely materials that could be found necessary for making games from photographs.

Magnifying glass An aid for accurately registering negatives for sandwiching or tone separation.

Masking film Large sheets of self-adhesive transparent film of very low tack, useful for masking prints when selectively tinting or toning.

Mat cutter A device with a 45° blade designed for cutting mat overlays from card.

Medium format camera For copying or multiple exposures; the larger negative size is easier to handle and gives a good quality image.

Mirror Can be used to produce symmetrical caricature pictures. The mirror is placed vertically on a print and the print is then rephotographed.

Mounting card Stiff card available in large sheets and in many colours, used for mounting prints.

Mounting press *see* Dry mounting press

Multigrade Ilford's variable contrast paper. It is particularly useful when used with burning and dodging techniques, as different parts of the print can be given different contrast ranges.

Multiple exposure device This is something many modern cameras do not have, yet it is invaluable for superimposing images in the camera.

Nail varnish Used to mask small areas of a print requiring toning or tinting, where a sharply defined edge is necessary.

Nail varnish remover The logical means of removing nail varnish from a print after use as a mask for toning or tinting.

Notebook An important means of recording creative ideas and processing notes.

Oil paints Can be used in place of bromoil pigments. Transparent oils are used for hand-colouring monochrome prints.

Outdated paper Photographic paper loses contrast with age and can sometimes be useful if a particularly soft paper is needed, for example for paper negatives.

Paint brushes A selection of brushes is useful, including a fine sable artists' brush for spotting prints and a 2½ in (6 cm) decorators' brush for coating gum bichromate emulsion.

Paints Water-colours and powder paints are suitable for hand-colouring techniques, etch bleach and gum bichromate; oil paints can be used for bromoil.

Palette An artist's palette is useful for spreading bromoil pigments and for mixing gum bichromate emulsions.

Paper towels Used for blotting surface water from a bromoil matrix prior to inking, or from an etch bleached print prior to colouring.

Petroleum jelly Smeared on glass, it forms an effective diffusion medium for soft focus effects.

Photo Mount Spray adhesive manufactured by Scotch for mounting prints. Be sure to use the permanent type.

Photo-tints Dyes made specially for retouching colour prints and tinting black and white prints.

Photocopier Underestimated as a tool for creative photography.

Photoflood A type of tungsten lamp, which provides lighting for copying prints and for exposing gum bichromate prints.

Photographic opaque Viscous orange paste used for 'blocking out' in negatives. Particularly useful for lith film, especially for pinholes.

Pins For piercing negative sandwiches prior to contact printing or tone separation to ensure accurate registration. Also for making pinholes in aluminium foil.

Plate An old plate is useful for spreading bromoil pigments and mixing gum bichromate pigments.

Plywood Rigid backing material for mounting prints, particularly when making clocks or games from them. Also for marquetry.

Pole cat fitch brush A bromoil brush, used for working the pigment into the matrix.

Polycontrast Kodak's variable contrast paper. It is particularly useful when used with burning and dodging techniques, as different parts of the print can be given different contrast ranges.

Polyurethane varnish Used to produce a high gloss finish on prints and marquetry.

Potassium bromide Common ingredient in many photographic formulations. Acts as a restrainer in developers and bleaches.

Potassium dichromate A photographic bleach, used particularly in bromoil and gum bichromate.

Potassium ferricyanide A photographic bleach, used for brightening highlights, and in sepia toning.

Powder paints Useful pigments for gum bichromate.

Pre-coloured monochrome paper Provides a simple means of introducing colour to a black and white image.

Printed circuit board Designed for electronic use, but can also be used for creative photography.

Printers' ink A substitute for bromoil pigments, which are no longer available.

Registration jig Home-made device for ensuring exact registration of two or more negatives or transparencies for sandwiching, contact printing or tone separation.

Resin-coated paper Particularly useful in montage, since the emulsion can be stripped from the plastic backing. It is also used in the etch bleach process.

Reticulated grain *see* Texture screens

Rotring pen A brand of drawing pens that is useful for lettering on a print mount, where sharply defined lines are required.

Rubber roller Used to ensure firm adhesion between glued or pasted components, for example mounted prints, montages and marquetry.

Safelight A yellow safelight is used for most monochrome printing; a red safelight is necessary for lith film.

Salt Used as a fixer for some fabric dyes.

Sandpaper Used in montage to thin the edges of the component prints, thereby avoiding shadows when copying the paste-up.

Scalpel A very sharp scalpel is necessary for cutting masking film, for montage and for marquetry. Also useful for retouching prints to remove black spots by gentle scraping.

Scissors Universally useful, but particularly so for montage.

Selenium toner Toner based on sodium selenide, which gives prints a purplish-brown colour and increases their permanence.

Sepia toner Toner based on sodium sulphide, which gives prints a rich brown colour.

Shaving brush The best substitute for a bromoil brush. The bristles should be cut to a flat, oblique surface before use.

Silk stockings Good diffusion medium for producing a soft focus effect during printing.

Silver pen Useful for lettering on a print mount.

Single-lens reflex camera The only useful camera for copying transparencies, when fitted with a macro lens, bellows or extension tubes.

Single-weight paper Being thin, it is ideal for use as a paper negative. Also preferable to double-weight paper for montage.

Slide copying attachment A device which enables a transparency to be held rigidly and perpendicularly in front of the camera lens for copying.

Slide mounts Glass slide mounts – of the Gepe type – are used for binding slide sandwiches.

Sodium dichromate A photographic bleach, sometimes used in gum bichromate instead of the potassium salt.

Sodium sulphide The toning agent in sepia toner. It reacts with the silver image to produce silver sulphide, which has a rich brown colour.

Sodium thiosulphate 'Hypo', the usual photographic fixing agent. Used plain – without a gelatin hardening agent – for bromoil.

Spatula An artist's spatula is needed to spread bromoil pigment thinly and to mix gum bichromate emulsions.

Sponge Occasionally useful in photography, such as for selective toning.

Spotting brush Very fine brush, used for retouching prints, or for applying photographic opaque to negatives.

Spotting medium A neutral black ink made for retouching prints. It can be diluted to match any shade of grey.

Spray adhesive Useful for mounting the components of a montage, for example.

Spray starch Sizing medium for art paper for use with gum bichromate.

Steel etch *see* Texture screens

Steel ruler Used with a craft knife or scalpel to ensure an accurate straight cut.

Sterling A brand of fibre-based paper, imported from India, which includes a particularly hard Grade 5.

Straight edge Used with a bevel cutter, or a craft knife or scalpel to ensure an accurate straight cut.

Sulphide toner Toner which gives a rich sepia colour.

Sulphuric acid An ingredient of bromoil bleach.

Tanning bleach Copper-based bleach used in bromoil which hardens the emulsion in proportion to the depth of tone in the original print.

T-Max Kodak T-Max is a very fine grain black and white film based on flat grain technology.

Texture screens Negatives of any size which contain an image of an even texture or pattern. When sandwiched with a conventional negative or slide and printed or projected, the texture or pattern is imparted to the final image. Texture screens can be bought with such patterns as reticulated grain, rough linen, steel etch and dot screen. Alternatively they can be home-made.

Tile A white ceramic tile is useful for spreading bromoil pigments and for mixing gum bichromate emulsions.

Toilet paper Can be used as a texture screen in creative printing or transparency making.

Toners Chemicals which react with the metallic silver of a monochrome print to produce a coloured substance. *See* specific toners – Blue, Selenium, Sulphide.

Tracing paper Can be used for tracing images from the camera's focusing screen, to give accurate registration with multiple exposures. Also for transferring a photographic image to a marquetry template.

Transparent oils The traditional way of hand-colouring a black and white print, which was much in vogue before the days of colour photography.

Tripod Essential for copying prints.

Typewriter correction fluid For example, Tipp-Ex. Useful for removing black spots from prints.

Ultraviolet lamp An alternative light source to sunlight for gum bichromate printing. Also used as the light source for exposing printed circuit board.

Variable contrast paper Paper such as Ilford Multigrade or Kodak Polycontrast where contrast can be varied by printing through different coloured filters. Useful with burning and dodging techniques if different parts of the print require different contrast ranges.

Varnish Used to produce a high gloss finish on prints and marquetry.

Veneers An attractive means of converting photographic images into marquetry.

Washing soda Used as a fixer for some fabric dyes.

Water Universal solvent for mixing up chemicals. In gum bichromate, water is used as the developer.

Water-colour paints Can be used for hand-colouring. In tubes, useful pigment for gum bichromate.

Water-colour paper Used for gum bichromate where hand-coating of the emulsion is involved.

Wet and dry paper For sanding down varnish between each coat.

White spirit For cleaning brushes after using oil paints, bromoil pigments or polyurethane varnish.

Wire Useful for holding a dodger in the enlarger beam. Thin but rigid wire is best.

XP2 Ilford's chromogenic film, which is noted for recording exceptionally sharp images. It is developed using colour processing chemistry.

BIBLIOGRAPHY

The following is a list of the publications – textbooks and magazine articles – which I have found of use as reference sources on creative techniques in photography.

BALL, C. W.: '**Line Conversion**', *Amateur Photographer*, 1 January 1969.

BALL, C. W.: '**Solarization**', *Amateur Photographer*, 15 January 1969.

BROADBENT, PAUL: '**Colour from Mono**' [etch bleach], *Photography*, March 1981.

BROOKS, A. E.: '**Bromoil by Brooks**', *Amateur Photographer*, 27 November 1974.

COE, BRIAN (Ed.): *Techniques of the World's Great Photographers*, New Burlington Books, London, 1981. ISBN 0 906286 45 X.

CRAEYBECKX, A. H. S.: *Gevaert Manual of Photography*, Fountain Press, London, 1962.

CROY, OTTO R.: *The Complete Art of Printing and Enlarging*, Focal Press, London, 12th edn., 1972. ISBN 0 240 44755 7.

DALLADAY, ARTHUR J. (Ed.): *The British Journal Photographic Annual*, Henry Greenwood & Co. Ltd., London, 1963.

DUCKWORTH, PAUL: *Creative Photographic Effects Simplified*, Amphoto, New York, 1976. ISBN 0 8174 0188 1.

EASTMAN KODAK COMPANY: *Creative Darkroom Techniques*, Kodak Publication No. AG-18, Rochester, New York, 1975. ISBN 0 87985 075 2.

HEISE, JIM: '**Painted Photographs – the Bromoil Way**', *You and Your Camera*, No. 85, 11–17 December 1980.

HORDER, ALAN (Ed.): *The Manual of Photography* [formerly *The Ilford Manual of Photography*], Focal Press, London, 6th edn., 1976. ISBN 0 240 50737 1.

HUMPHREY, CAL: '**Carry on Bromoiling**', *Amateur Photographer*, 5 April 1978.

KING, TERRY: '**Old Recipes Are Best**' [gum bichromate], *Amateur Photographer*, 17 December 1983.

KRASZNA-KRAUSZ, A. *et al.* (Eds.): *The Focal Encyclopedia of Photography*, Focal Press, London, 1972. ISBN 0 240 50680 4.

PETZOLD, PAUL: *Effects and Experiments in Photography*, Focal Press, London, 1973. ISBN 0 240 50763 0.

SPILLMAN, RONALD: '**Posterisation**', *Amateur Photographer*, 4 January 1978.

SYMES, C. J.: *Bromoil and Transfer*, Fountain Press, London, 1946.

TRAPMORE, ALISON: '**Bromoil Printing**', *Amateur Photographer*, 17 December 1983.

VERSTER, WYNNE: '**The Gum-Pigment Process**', *The Photographic Journal*, March 1982.

WHALLEY, GEOFFREY E.: *An Introduction to Bromoil and Transfer*, James A. Sinclair & Co. Ltd., London.

WILLIAMS, T. I.: *Pigment Printing Processes*, Royal Photographic Society, 1978.

INDEX

Italics denote titles of pictures

acacia 96, 148
acetone 59, 148
adhesive
 spray 51, 103, 153
 woodworking 128
adhesive tape 78, 114, 127–8, 148,
 149
Agfa Brovira 14, 23, 136, 148
agitation 82
airbrush 59, 60, 63, 64, 87, 148
aluminium foil 138–9, 148
ammonium dichromate 99, 148
Andy Capp 74
Angel from Hell 16–17
aperture 24, 36, 138–9
Apron Pocket, The 54–5
Arab 126–7
artwork, camera-ready 122

background, removal of 90–91
bas-relief 72–3
Beanz 121
bellows 39, 148
Best Foot Forward 100
Between Races 109–111
bevel cutter 60, 103, 114, 119, 148,
 151
bichromate, gum *see* gum
 bichromate
bichromates 96, 99
bleach
 bromoil *see* bromoil
 etch *see* etch bleach process
 tanning *see* bromoil
blocking out 69, 70, 77
Bonfire Night 34–5

boot polish 60
Bowens Illumitran 39, 150
bromide ions 80, 82
bromoil 92–6, 100
 bleach 92, 94, 153
 brushes 92, 94, 148
 matrix 94, 96
 pigments 92, 94, 96, 148
 transfer 96
brushes
 hog hair *see* bromoil brushes
 pole cat fitch *see* bromoil
 brushes
 shaving 94, 152
 spotting 153
Burial on the Mount of Olives
 94–5
burning and dodging 17, 25–9, 87,
 108
By the Mere 20, 23

Camels 44–5
camera
 copying 149
 large format 31
 medium format 31, 151
 pinhole *see* pinhole camera
 single-lens reflex 39, 138, 152
Camera Club Judge, The 120–21
camera shake 136
Candles 139
Canon AE1 139
card
 grey *see* grey card
 mounting 102, 151
Carolus Rex 32–3

Centre of Attention 109
changing bag 138
charcoal 87–8, 148
Check Mate 8
chemicals
 care with handling 7, 57
 mixing 7
Chinaman in a Mask 48
Chinese 128
Chinese hair pen *see* pens
chloroform 59, 148
Christmas cards 122–5
chromogenic film *see* film
Cibachrome 56, 121, 149; *see also*
 Ilford Ilfochrome
citric acid 64, 149
Clock Works 132–3
clocks 130–33, 149
close-up
 lens 39, 149; *see also* macro lens
 photography 39
collage 55
colloids 96
Colour Construction 66–7
colour
 printing 36, 56
 prints, retouching 66
 processing chemistry 13
 slides *see* transparencies
 temperature 40
colouring, hand *see* tinting
Conspirators 28–9
contact printing 70, 72–3, 75, 77,
 80, 82, 83, 87, 92, 101
contact printing frame 70, 73, 78,
 100, 101, 149

contrast
 control of 12–25, 87, 90–92, 134
 extreme *see* lith film
 grades of *see* photographic paper
conversion tables, temperature/
 time 19
copier, slide *see* slide copier
copper, metallic 57, 139–40
copper sulphate 64, 94, 149
copying 14, 23–5
 consistency of colour in 40
 exposure determination for 40
 lighting for 40, 52
 negative 23, 25, 68–70
 print 23–5, 133
 transparency 36, 38–40
copying film *see* film
Cow gum 59, 103, 149
Crystal Gazer 96–9
crystals in developer 140–42

Daguerre 86
Daphne 20–21
Dawn Flight 23
daylight 40, 96, 99
Demons 52–3
denim 60–61
depth of field 39
derivatives, second generation 73
developer
 bromide 18
 chemistry of 80
 choice of 12, 13
 concentrated 17
 crystals in *see* crystals in
 developer
 dilute 17, 83, 149
 extreme contrast 18; *see also*
 developer, lith
 fine grain 13
 lith 18–19, 68, 83, 151
 print 68, 83
Dignity 109–10
dodgers 27, 149
dodging *see* burning and dodging
dot screen *see* texture screens
drawing
 board 122, 149
 ink *see* inks
 paper *see* paper
 pens *see* pens
dry mounting
 press 60, 103, 128, 149

tissues 103, 149
Dungarees 61
dye toners *see* toning
dyeing *see* tinting
dyes 57, 60, 63, 149
 fabric 60, 62–3, 112, 114, 121,
 130, 149, 150
 food 60, 64, 66, 150
 water-based 67
Dylon *see* dyes, fabric

electronic flash *see* flash, electronic
electrons 80
emery paper 128, 133, 149
emulsion
 coating of 96, 99–101
 differential hardening of 94
 grain and contrast
 characteristics of 12
 reticulation of 19; *see also*
 reticulation
 sensitivity of 12
 sensitization of 82
 speed of *see* film speed
 stripping of 63–5, 100
Enchanted 38–9
Encounter in the Rain 116–17, 121
enlargement, selective 27
etch bleach process 56, 63–7, 149
etching 92, 140
exposure
 calculation 40
 meter *see* meter
exposures
 long 13, 24, 36, 92, 101
 multiple *see* multiple exposure
extension
 bellows *see* bellows
 tubes 39, 149

F.U.s 61
fabric surrounds 60–61
Faces at the Races 108
Fan, The 114–15, 121
felt-tip pens *see* pens
Fenton, Roger 86
'ferri' 150; *see also* potassium
 ferricyanide
ferric
 ammonium citrate 60
 chloride 140, 150
 ferrocyanide 57, 60
ferricyanide *see* potassium

film
 chromogenic 13, 149
 colour 68
 copying 23, 24, 149
 daylight-balanced 40
 extreme contrast 25, 32
 fast 12, 24
 free 87
 Gratispool *see* Gratispool film
 lith *see* lith film
 masking *see* masking film
 orthochromatic 68
 outdated 23
 overdevelopment of 19, 20; *see
 also* push processing
 panchromatic 69
 processing of 12
 recording 13
 sheet 68, 78
 slow 12, 13
 underexposure of 19; *see also*
 push processing
 uprating of 19–20, 23; *see also*
 push processing
film speed 12, 13, 138
filters
 close-up *see* close-up lens
 colour printing 56
 variable contrast 14, 29, 150
Financial Wizard 2, 118–19, 121
fixer 68, 82, 94, 150
 hardening 94
 plain 94
 see also sodium thiosulphate
flash, electronic 40, 70
flat-grain technology 13
Flower 42–3
*Focal Encyclopedia of
 Photography* 57
focal length 138
focusing screen 31, 150
fogging 129
Fox Fur – and Rita 58
Fox Talbot 115
framing 103, 133
Frisk *see* masking film

games 129–30
gelatin 12, 94
Ghost Town 18–19
gold, metallic 57
grades of paper *see* photographic
 paper

grain
 control of 12–25
 enhancing 13, 40
 fine 13
 flat 13
 size of 13
graininess 12–13
grains
 clumping of 12–13, 19
 silver 12
graphic arts 68
Gratispool film 87
greaseproof paper *see* paper
grey card 150
gum arabic 96, 100, 150
gum bichromate 96–101
gummed tape 127, 150

Hallucination 36–7
hand-colouring *see* tinting
Hill, David Octavius 86
hog hair brush *see* bromoil brushes
holding back *see* burning and
 dodging
Holiday Slide 64–5
Homeless 77–9
hopping 96
hydrogen peroxide 64, 150
hydroquinone 68
hypo 94, 150; *see also* fixer

Ilford
 Delta 13, 149
 FP4 20, 23, 136, 150
 HP3 23
 Ilfobrom 17, 150
 Ilfochrome Classic 56, 150; *see
 also* Cibachrome
 Manual of Photography 57
 Multigrade 14, 151
 XP2 13, 153
inertia *see* photographic paper
inks 60, 63, 64, 66, 87, 94, 149,
 150, 152
instructions, manufacturers' 13,
 19, 57, 60–61
Inter-City 106–7
ions *see* bromide *and* silver
iron, domestic 103, 150

jig *see* registration jig

kaleidoscope pictures 52–3

Kentmere
 Art 94, 150
 Kentint 56, 150
Kiss, The 40–41
Kodak
 Kodalith 68
 Polycontrast 14, 152
 T-Max 13, 153

Lair of the Cave Monster 112–13,
 121
Lakeside 24
lamp
 photoflood *see* photoflood
 lamps
 ultraviolet *see* ultraviolet light
latent image 63, 80, 82, 96
lead chromate 57
lens
 close-up *see* close-up lens
 macro *see* macro lens
 supplementary 39
lens-cleaning tissues *see* tissues
Letraset *see* lettering
lettering, rub-down 122, 150
light box 78
lightproof box 33, 150
line conversion 72–3
linseed oil 151
lipstick 60, 151
lith
 developer *see* developer
 film 14, 18, 25, 32, 34, 38, 50,
 64, 68–85, 99, 101, 135, 139–
 40, 151
 masks 75–9
lithography 68, 92
Luminos 94

Mackie line 82
macro lens 39, 151; *see also* close-
 up lens
magnetic materials
 for double glazing 130
 for wall planner 130
magnifying glass 78, 151
marquetry 126–8
mask, lith *see* lith masks
masking 58–9, 60–61
 film 59–60, 61, 63, 64, 69, 90,
 114, 150, 151
 frame 32
mat

cutting, freehand 103, 114, 119
 overlay 103, 121
 see also bevel cutter
matrix *see* bromoil
mats, table 127–8
meter
 exposure 44, 149
 flash 40
 through-the-lens 40, 138
mirror 142–3, 151
Mirror Image 69
mirror images 142–3
Miss World Contest 107
montage 30, 45–55, 70–71
 in situ 53–5
mordants 57
mounting
 card *see* card
 press *see* dry mounting
 tissues *see* dry mounting
mounting
 creative 60, 63, 102–121
 dry *see* dry mounting
 interactive 112–121
 multiple 103–7
 window 102
multiple exposure
 facility 30, 151
 in the camera 30–32; *see also*
 multiple printing
multiple printing 32–3, 36, 101,
 130

nail varnish 59, 151
 remover 151
National Museum of Photography,
 Film and Television 109
negatives
 copying *see* copying
 density of 19
 fine grain 19
 full-tone 82–3
 lith *see* lith film
 paper *see* paper negatives
 sandwiching *see* sandwiches
 separation *see* tone separation
 underexposed 17, 74
 unsharp 40–41

oils, transparent *see* paints
opaque, photographic *see*
 photographic opaque
Oriental Seagull Grade 5 14

orthochromatic film *see* film
overlay *see* mat overlay

PCB *see* printed circuit board
paintings 86
paints 60, 63, 66, 87, 151
 aerosol 69, 90, 148
 oil 94, 151
 powder 100, 152
 transparent oil 153
 water-colour 100, 153
panchromatic film *see* film
paper
 coloured 149
 drawing 32, 100
 fine art 96
 greaseproof 44, 150
 photocopier 135
 photographic *see* photographic
 paper
 sizing of 100
 textured 122
 tissue 44
 toilet 44–5, 153
 tracing 31, 153
 water-colour 100, 101, 130, 153
paper negatives 14, 64, 66, 87–92,
 100, 101
Paterson
 Acutol 20, 23, 148
 texture screens 40–42, 125
pencils
 6B 88
 coloured 60, 149
pens
 drawing 122, 152
 felt-tip 60, 64, 87–8, 112, 150
 hair 148
 Rotring 122, 152
pentaprism 31
permanence, increasing 57
petroleum jelly 44, 151
photo-opaque *see* photographic
 opaque
photo-tints 66, 151
photocopier 134, 151
photocopies, backlit 134–7
photocopying 107, 122, 134–7
photoflood lamps 100–101, 151
Photographic Alliance of Great
 Britain, The 119, 121
photographic opaque 70, 77–8, 151
photographic paper

bromide 18, 87
C-type 56
colour 56, 149
colour reversal 56
double-weight 92
glossy 94
Grade 0 14, 87–8
Grade 1 14, 90
Grade 4 14
Grade 5 14, 17, 23, 90–91
Grade 6 14, 23
Grades of 14
hard 14, 17, 23, 129
inertia of 33
outdated 151
pre-coloured 56, 152
resin-coated 48, 51, 56, 63–4, 94,
 100, 152
single-weight 46, 92, 152
soft 14, 87, 92
variable contrast 14, 29, 153
photographs
 Victorian 86
 'while you wait' 87
photomontage 45–52; *see also*
 montage
photoresist 140
pigment processes 92–101
pigments 66, 86
 bromoil *see* bromoil
 oil-based 92, 94, 96
 water-based 96, 100, 101
'pin holes' 70
pinhole camera 138–9
pole cat fitch brush *see* bromoil
 brushes
Pollution 59
polyurethane varnish *see* varnish
Positive and Negative 70–71
posterization 82–5
potassium
 bromide 58, 64, 94, 152
 dichromate 94, 99, 101, 152
 ferricyanide 58, 60, 152
pouncing 96
presentation of prints 102, 107; *see*
 also mounting
printed circuit board 139–40, 152
printing
 colour *see* colour printing
 commercial 122
 contact *see* contact printing
 multiple *see* multiple printing

prints, copying *see* copying
processing
 push *see* push processing
Prussian blue *see* ferric
 ferrocyanide
Punks at Ascot 112
push processing 14, 19–23, 24

quality
 pictorial 11, 13
 technical 11, 13

Racing Colours 62–3
Rained Off 136–7
reciprocity failure 139
reducing agents 80
registration 34, 72–3, 75, 77, 78,
 82, 84
 jig 78, 152
Remembrance 88–9
reproduction ratio 39
resolution 13
reticulated grain *see* texture
 screens
reticulation 19
roller, rubber 51, 152
Rooftops 80–81
Rotring pen *see* pens
rough linen *see* texture screens
Royal Holloway College 31
ruler, steel 153
rules 145

Sabattier effect 80–82
safelight 12, 100, 152
safelight, red 68, 82
salt 63, 152
Salute 90–91
sandpaper 46, 152
sandwiches 30, 33–45, 72–3, 75,
 78, 84
 negative 30, 36
 transparency 30, 36–9, 44
scanning 122
Scotch Photo Mount 103, 151
selective toning *see* toning
selenium toning *see* toning
Self Portrait 50–51
Self Portrait with Graffiti 6
sensitivity *see* emulsion
sepia toning *see* toning
Sergeant Major 142–3
shading *see* burning and dodging

sharpness 25, 39
shaving brush *see* brushes
sheet film *see* film
shellac 103
shutter 30
silhouettes 67, 82, 103
silver, metallic 12, 56, 57, 80
silver
 bromide 80
 halides 12, 80
 ions 80, 82
 salts 57, 86
 selenide 57
 sulphide 57
 thiosulphate 82
 uranium ferrocyanide 57
Sinclair 94
single-lens reflex camera *see*
 camera
Sleeping Partner, The 46–7
slide
 copier 39
 copying attachment 39, 152
slides, colour *see* transparencies
soda, washing *see* washing soda
sodium
 dichromate 99, 152
 sulphide 58, 152
 thiosulphate 82, 94, 152
solarization 80–82
South Door 75–7
Spectacles 107
Splash! 84–5
spotting medium 153
sprocket holes 78
Star Singer 140–41
starch 100, 153
steel etch *see* texture screens
Steep Holm from Sully Island
 14–15
Sterling Grade 5 14, 23, 129, 153
stockings 44, 152
Stone Gables 72–3
Striking the Postillion 144
sulphide toning *see* toning
sulphuric acid 60, 94, 153
superimpositions 30–33

supplementary lens *see* lens
sympathetic surroundings 107–12

table mats *see* mats
Taking his Time 130–31
tanning bleach *see* bromoil
temperature
 colour *see* colour temperature
 development 12, 19
temperature/time conversion tables
 see conversion tables
texture screens 14, 40–45, 125, 153
 dot 42, 149
 making 42, 44
 non-photographic 44
 reticulated grain 40–42
 rough linen 125
 steel etch 42
Threepenny Opera, A 26–7
through-the-lens meter *see* meter
tinting 56, 60, 62–3, 88
tinting, selective 63
tints, photo- *see* photo-tints
tissue paper *see* paper
tissues
 dry mounting *see* dry mounting
 lens-cleaning 42–3, 150
toilet paper *see* paper
tone
 line 73–4
 separation 82–5, 99, 126–7
toners *see* toning
toners and their effects 57
tones, intermediate 25–7, 68, 73,
 83, 94, 134
toning 56, 57–60, 63
 blue 57, 60–61, 148, 150
 copper 57
 dye 57
 gold 57
 green 57
 iron *see* toning, blue
 lead 57
 metal 57
 metal salt 57
 mixed 57
 red 57

selective 58, 60–61
selenium 57, 152
sepia 57, 58–9, 88, 152, 153
 sulphide *see* toning, sepia
uranium 57
vanadium 57
yellow 57
tracing paper *see* paper
transparencies
 copying *see* copying
 sandwiching *see* sandwiches
 unsharp 42–3
transparency
 copier *see* slide copier
 mounts 34, 152
transparent oils *see* paints
tripod 13, 23, 24, 153
tubes, extension *see* extension
 tubes
Tying Up 92–3
typewriter correction fluid 87, 153

ultraviolet light 101, 140, 153
uprating *see* film

vanadium ferrocyanide 57
varnish 128, 133, 153
 nail *see* nail varnish
 polyurethane 133, 152
veneer 126–7, 153

washing soda 63, 153
water-colour
 paints *see* paints
 paper *see* paper
Welcoming Party 42
'wet and dry' *see* emery paper
Winners and Losers 48–9
Winning Streak, A 103–5

Xerography 135
xerography, creative 134

Young and the Old, The 22–3

Zebra's Tail, The 129